Alice Fox works with found, foraged, gathered and grown materials to create beautiful and intricate woven artworks that are inspired by, and made from, nature. In this practical guide, Alice demonstrates how using simple tools and technology, as well as making use of locally sourced and unconventional materials, can produce exciting results which resonate with a strong sense of place.

Wild Weave covers a range of things from the historical background of weaving to how it crosses boundaries between basketry, art and craft. Also included is plenty of instructional information including an introduction to simple tools and basic equipment that can be utilised from around the home, tips for sourcing materials, a guide to weaving on frames, techniques for working with difficult materials which may be rigid or fragile, and examples of weave-based ideas for recording the landscape.

A masterclass in creativity, this book, illustrated with beautiful examples of work from the author alongside other leading practitioners, demonstrates how to harness the spirit of nature in textile art and to imbue your own woven artworks with vitality and meaning.

WILD WEAVE

Seed sample, 2024.
Weave in linen with
germinated flax seeds.
7×7×7cm (2.8×2.8×2.8in).

WILD WEAVE

Alice Fox

BATSFORD

Contents

Foreword 6
Introduction 9

Chapter 1:
Simple Tools 14

Chapter 2:
Order and Chaos 24

Chapter 3:
Stitched Weave 34

Chapter 4:
Dimensional Weave 46

Wild Weavers 72

Chapter 5:
Ephemeral 78

Chapter 6:
Material Choice 92

Wild Weavers 98

Chapter 7:
Weaving Place 106

Last Thoughts 116

Glossary 118
Notes 119
Further Reading 120
Resources 121
Contributors 121

Appendix: *Clutch* materials and techniques 122
Acknowledgements 124
Picture Credits 124
Index 126

Foreword

Building on my previous books, *Natural Processes in Textile Art* and *Wild Textiles*, this new volume aims to foster a spirit of experimentation in approaching weave projects, expanding in particular on some of the weave-based ideas from *Wild Textiles*. By engaging with simple tools and technology, we can create exciting and innovative artworks. By taking an open-minded and informed approach to resources, we can make use of what is available locally and be experimental with unconventional materials.

Much of the work featured in *Wild Weave* is made of found or gathered materials, mostly plant-based and often sourced from my allotment plot, or gathered in different locations as part of my creative engagement with place. The colour palette of these plant fibres (and therefore this book) is a beautiful range of neutrals – golden yellows through to toasty browns. Many of the samples created specifically for the book are made from white paper yarn, one of the few commercially made materials I use from time to time. I like its simplicity, its subtle colour, so that the structure is to the fore, and its interplay of strength, rigidity and flexibility; its crispness forms a welcome contrast to the more organic qualities of many of the other found and gathered materials that I work with.

The wild weavers whose work I have chosen to feature here are included because of their unconventional approach to either materials or woven process and form. They are all artists whose work I admire, and I'm pleased to have their beautiful output in among my own.

Right: Studio table with samples, tools and work in progress.

7

Introduction

Why weave?

'That we can weave a fabric, "material" as we so often call it, from the barely two-dimensional form of a thread, is a miraculous cooperation between human ingenuity and the resources of our natural environment.'[1]

Weave is embedded in our culture and our lives. We wear woven cloth every day and use functional woven objects in our homes without a second thought. Terminology from textile and weave processes are embedded within our language, with regional nuances that reflect the textile heritage of our landscapes and society. We weave stories and threads of thought. Some weave webs of lies and deceit. We admire the beautifully woven webs, cocoons and nests of the wildlife living alongside us. Weave is all around, whether we notice it or not.

'A rigid set of parallel threads in tension and a mobile one that transverses it at right angles'[2] is how influential textile artist Anni Albers described the structure that has remained fundamentally unchanged, despite technological advances in the methods used to create it, over the 4,500 or more years that humans have been weaving.
To weave is to form a fabric by interlacing long threads passing in one direction with others at a right angle to them. One set of threads is called the warp and the other, the weft. From this most simple starting point, weave can go in many different directions: from a balanced plain weave cloth, to an intricate pattern created by a complicated weave structure; from weft-faced tapestry weave (where the warp is completely hidden by the weft threads beaten hard to create a tight, solid surface), to many different types of rug, carpet or hanging. In basketry, too, similar principles are at play, but with a more rigid set of materials. Whether weaving cloth or baskets, some sort of tension is usually required, either keeping the warp threads taut on a loom or frame, or using the body somehow to create the tension, as in the use of a back strap or by using the hands to tension a weaving element in many basketry techniques.

For millennia spinning and weaving were common household activities born out of necessity. They were largely undertaken by women due to the repetitive nature of the tasks and their compatibility with childcare[3]. The production of a woven structure by hand is inherently time-consuming.

'As a result of the time invested in the creation of woven textiles and the intimate associations we have with their materials, textiles often feel as though they are imbued with something more than the technical accomplishments of their creation.'[4]

We no longer *need*, individually, to weave cloth to keep ourselves warm and protected or for gathering the provisions we need to stay alive. We might still *choose* to weave functional cloth, enjoying the process of creating and developing skills. We might weave to tell stories, share a narrative, keep traditions alive, or to create something beautiful to live with or to gift. Some of us find ways of making a living doing so. Finding connection with material and working with our hands is something we are, perhaps, more aware of than ever in our increasingly digital age.

Left: Arc ii & Arc iii, 2024. Apple wood, twining in bindweed. 35×15×20cm (13.8×5.9×7.9in).

Why wild?

'We touch things to assure ourselves of reality. We touch the objects of our love. We touch the things we form. Our tactile experiences are elemental.' [5]

To work with the hands, to form a structure or surface with something that is not far removed from its original and wild state, is something that grounds us as inherently creative beings. In creating something woven that is not purely about function, surely the magic happens in our choice of materials. We can select materials for their colour, their presence or their weight. We can also choose them for their ability to tell a story or carry a message, for their relevance to an experience or to the place they came from. With a little imagination and creativity, there is always room for pushing things along a less-travelled path, as expressed by Jessica Hemmings:

'I understand the weavers' vision to be… an ability to work within the discipline and logic of weaving, while remaining alert to serendipity and trusting creative intuition.' [6]

I often use the word 'wild' in reference to materials that are gathered from the land, whether plant fibres or animal. The majority of the materials I use in my practice are plant-based, and these I have grown or gathered myself, often from my allotment (garden) plot. This connection to the land through the materials I choose to work with is fundamental to my practice and to the sustainable approach I wish to take. I wrote extensively about this approach in *Wild Textiles*, and whenever I refer to plant fibres in *Wild Weave*, you will find more information about how to gather or process those fibres there. Many of the samples in *Wild Weave* use gathered materials that may not suit more conventional textile structures.

> **WILD**
> *Adjective*
> 1. (of an animal or plant) living or growing in the natural environment; not domesticated or cultivated
> 2. (of a place or region) uninhabited, uncultivated or inhospitable
>
> *Verb*
> 3. Behave in an unrestrained manner

'Wild' is also used here to reflect an unconventional approach, perhaps to materials, but also to techniques and structures. We can take a basic understanding of a woven structure and throw out any rules beyond that. Being playful, experimental and making sideways connections can take us along a wild, winding pathway. By taking our weave off the loom, we can liberate a structure from the two-dimensional, allowing us to create in a more intuitive way. In this book we will explore a variety of ways to achieve this freedom to construct creatively.

Right: Working hands with grasses.

Found natural materials as inspiration for weave.

Opposite above: Pine needle bundle.

Opposite below: Moorland grass fragment with roots.

Below: Globe artichoke seed head fragment.

Chapter 1
SIMPLE TOOLS

Opposite: Daffodil Strip Cloth (detail), 2023. Woven daffodil leaf on spun nettle fibre warp, strips joined with daffodil leaf stitch. 16×16cm (6.2×6.2in).

A Simple Wooden Frame

One of the wonderful strengths of weave is that it can be undertaken on such widely differing scales and still have impact; this quality and the range of possibilities is epitomized so magnificently in the work of Sheila Hicks. Her work on an architectural scale shows how textiles can be installed in large spaces, with all the mechanics and engineering that must go along with it, yet with playfulness and innovation; however, it is her small and intimate works that I find most moving. As Nina Stritzler-Levine says, 'Hicks herself ignores categorization, choosing whatever medium she wants to work with and frequently entering unmapped areas.'[7] Most of these small works – referred to by Hicks as 'miniatures', but also as 'personal expressions', 'private investigations' and 'ramblings'[8] – are woven on a small, portable, wooden frame, with nails for tensioning the warp threads. This frame travels with her, home and away, performing the function that a sketchbook might for many artists. The use of this simple piece of equipment is so very inspiring in Hicks' practice, along with her trio of constants – a huge range of threads, found materials and an ever-inquiring mind.

Although looms of varying technology and complexity enable us to make wonderful cloth with evenness and pattern, there is something I find very attractive about paring that right back and using the most basic equipment. A wooden frame must be that most rudimentary tool, and yet this meeting of four pieces of wood can enable us to create so much.

While a table loom or more substantial floor loom could well be used to weave with found and gathered materials, all my work featured in this book is made using very simple equipment. I do have a floor loom and a four-shaft table loom, as well as a rigid heddle loom – these have been accumulated over the years, either inherited, rescued or gifted – but currently I prefer to work on a smaller scale and in a more intuitive way, often with small groups of any one material. Weaving on a frame generally allows for this investigative approach. Although this is weaving with the most basic equipment, it doesn't mean it can't result in intricate and beautiful work.

Choosing what tools to work with might be a direct result of the materials you are wanting to incorporate into your weave. This choice could also be based on the equipment you have available to you – there is usually some room for improvisation. Found, homemade and repurposed structures can become well-loved and well-used pieces of equipment. Rather than being a list of things you must have, the following should serve as an explanation of various tools and an illustration of how little you really need to work with.

Opposite: Wooden frame with two narrow warps and tensioning threads in cotton. Left warp wrapped round whole frame. Right warp attached to frame in pairs. Horizontal threads tension and stabilise both warp sets. 26×20cm (10.2×7.9in).

17

Above left: Rigid heddle for weaving bands or strips. 15×17cm (5.9×6.7in).

Above right: Wooden egg former. 10×7×7cm (3.9×2.8×2.8in).

Left: Wooden frame loom with teeth to hold warp threads in place. 11×9cm (4.3×3.5in).

Clockwise from above right:
Card strips for stabilising materials during weaving. Dimensions variable.

Wooden egg former. 6×4.5×4.5cm (2.4×1.8×1.8in).

Pin loom formed from wooden off-cut and panel pins. 16×8×3.5cm (6.3×3.1×1.4in).

Wooden comb for beating small scale weave. 7×3.5cm (2.8×1.4in).

Above: Card with pins forming a simple pin loom. Small wooden pegs for stabilising materials during weaving. 7×9cm (2.8×3.5in).

Below: Wooden frame holder with metal clamp, one of a pair for holding and angling weaving frame. 28×11×5cm (11×4.3×2in).

Frames A simple wooden frame can easily be constructed specifically for weaving use, or can be repurposed from a variety of other objects (picture frames or deconstructed furniture, for example). A frame enables you to work in a tapestry-weave style, where you can either create a simple shed, with a stick or by lifting warps with your fingers, or you can weave in and out on a small scale using a large needle. Tapestry or rug weavers will often work on a frame to sample designs, textures, etc., before scaling up and working on a larger loom. Warp threads can be wound round the whole frame and then brought together into a single warp surface, using tensioning threads across the bottom. Alternatively, threads can be attached to the top of the frame in doubled-over pairs and then tied on at the bottom, again in pairs. This creates a flat surface, level with the front of the frame, and this is how I usually attach a set of warp threads for a technique such as wrapped twining (see page 40).

Pin looms These, in their simplest form, are nails banged into a piece of wood or pins pushed into the ends of thick card (see page 19 and the image opposite, top). A frame can also be altered to create a pin loom, by banging in nails at the top and bottom, or at regular intervals all the way round the frame. This allows threads to be held slightly away from the frame and gives the advantage that you can weave right up to the edge of the piece. This technique can be used for plain weave as well as random weave (see page 26–30) and can allow for quite an experimental approach. The pieces I weave in one continuous warp-weft structure are made on a frame pin loom, allowing me to weave one piece of cordage as warp and then weft, adding on to the string as I weave. Once finished, the whole constructed surface can be slipped off the nails and will hold itself together.

Clamps Useful to hold your frame in place on a table, allowing you to walk away or stand back from the work without having to move it. Angled clamps can be purchased specifically for holding a weaving frame and these have the advantage of being adjustable, to shift the angle and position of your frame as your work progresses or the light changes. Alternatively, large G-clamps from DIY stores can be used to clamp the frame to the table in an upright position. If neither are available, then just resting the frame on your thighs and against a table will enable you to work at the frame.

Heddles For creating a shed in the warp so that you can weave backwards and forwards. A simple rigid heddle loom will enable efficient weaving on a warp that is longer than you might fit on a frame, allowing for larger work to be made. This will suit working with soft materials, as the warp and the woven cloth are wound onto beams at the front and back of the loom. The heddle is moved between higher and lower positions on the loom alternately as you weave across your warp. A rigid heddle can also be used to weave narrow bands or strips without a loom, as long as you can secure your warp to something that will give you tension. This can be as simple as hooking it onto a door handle a little way from where you are sitting and then onto your belt, so that the position of your body gives you the required tension, and the heddle is then raised and lowered as you weave. This is a technique known as band weaving.

Beaters Often necessary to ensure your weft sits evenly across the warp. On a loom, this is an integrated part of the structure, but if you are weaving on a frame or other improvised arrangement you can use a large needle, a fork or other such implement. Tapestry weavers, who will generally beat their warp hard so as to cover the warp entirely, will often use a repurposed metal fork or a wooden bobbin, which can also carry lengths of weft thread. If I am weaving on a small or narrow scale, I am often working with a large needle; this allows me to feed my weft through the warp and I can then use it to beat or press the weft in place as I go (I have a selection of handmade wooden needles that I like to use for this, too – they feel good in the hand).

Formers Used in many basketry situations, these can be useful for weaving in three dimensions. Anything that is relatively solid and the right size and shape for your desired form could be used, and examples might include a wooden darning egg, a found pebble, a bowl or vessel from your home, or a scrunched-up ball of paper. Alternatively, fill a bag with rice and tape it to create the shape you want (this can then be snipped and emptied out once you've finished weaving).

Card and clips I often use strips of card to hold materials steady when I start to weave. This is especially useful if I'm working with plant material as my warp (see page 113). Placing a piece of card either side of the stems and clipping them in place with bulldog clips helps to control everything while I get my first few rows of weaving or twining in place. Once the unconventional 'warp' has been secured with a few lines of weaving, it is usually possible to remove the card and continue weaving.

Needles, bodkins, shuttles and bobbins All are items that different weavers might choose to use in different situations. The choice of small-scale weaving aids is quite a personal decision and might vary depending on what structure you're weaving and the materials being used. Sometimes just pushing things through with your fingers is all you need. As experience grows, however, you may find a particular tool that sits well in your hand or helps with a particular structure. I often weave with a tapestry needle or bodkin. This suits the scale I regularly work at and provides me with a certain amount of accuracy in terms of moving soft materials through small gaps in warp or weft. Weaving with a needle feels right to me as I came to this point via a largely stitch-based textile background. I recently started making my own wooden needles from prunings of wood from my allotment. The idea of making some of my own tools appeals greatly to me; however, I will use whatever best fits the task from my box of appropriate tools.

Below: Tool roll with a variety of needles, pins, netting needles, sticks, shuttles, bobbins, clips, hooks, beating fork and other tools. 44×22cm (17.3×8.7in).

Chapter 2

ORDER AND CHAOS

Opposite: Dandelion Weave 3 (detail), 2021. Dandelion stems (*Taraxacum officinale*).

Stems, gathered after flowering, dried, manipulated to form cordage and then woven together in one continuous warp/weft structure.

Order – Plain Weave

The balance and order of plain weave – each thread passing over, then under a set of perpendicular threads in turn, alternately to the previous row – is basic, and yet so much variation and expression can still be achieved through this structure. When I was studying weave as part of my textiles degree, we were encouraged to explore many weave patterns. Although these different structures achieve beautiful patterns and qualities in the cloth, I often felt that plain weave was enough for me, with its potential for interest through variation in material choice, weight of yarn, spacing of threads, and so on. I then discovered tapestry weave and found that the solidity of the surface that could be created through beating down the weft was extremely satisfying and provided three-dimensional possibilities. Again, with tapestry weave there are many potential variations in the structure and so many material possibilities – anything goes! I find myself coming back time after time to the most simple and subtle of surfaces, where the nuances of material are laid bare and the detail of the surface texture is all-important.

Plain weave process

Plain weave can be worked in a variety of ways, using simple tools to create tension and support during weaving, as seen in the list below:

- By using a loom (floor, table, rigid heddle, etc.) where the heddles raise alternate threads in turn, creating a shed through which the weft is passed. The cloth is beaten after each pass of the weft to create an even cloth.
- By working on a frame, passing the weft through the warp threads, perhaps with a bobbin, a shuttle or a large needle, depending on the scale of working.
- By creating a warp round a piece of card, securing the start and finish at the back, and wrapping the thread evenly around (see the example on page 29). This can then be woven through with a chunky needle.
- By using a pin loom, essentially a piece of wood or a wooden frame with small nails in. The warp is wound round the pins in turn and the weft is taken through these, and the whole structure is lifted off the pins after weaving.
- Dressmaking pins with round heads fixed in the end of a sturdy piece of card can be used in a similar way to a pin loom, winding the warp round each pin in turn.

Opposite: Plain weave in paper yarn with staining from oak gall ink, 2023. Part of *Book Marks* series. 20×6cm (7.9×2.4in).

Below: Weave samples, 2018. Linen weft on cotton warp. 23×15cm (9.1×5.9in) & 17×15cm (6.7×5.9in).

Above left: Pin loom formed from wood off-cut with panel pins. Plain weave in one continuous thread, forming warp and weft in paper yarn, 2024. 22×9×3cm (8.7×3.5×1.2in).

Above right: Balanced plain weave in one continuous thread, forming warp and weft in paper yarn. Sample woven on a pin loom, 2024. 7×7cm (2.8×2.8in).

Below: Plain weave in linen with natural dye, 2018. Weft has been beaten to cover warp, tapestry weave style. 7×8cm (2.8×3.1in).

Above: Plain weave in paper yarn with weft beaten to cover warp. Sample woven on a pin loom, 2024. 7×7.5cm (2.8×3in).

Middle: Plain weave in paper yarn. Warp formed by wrapping round cardboard, 2024. 11×11.5cm (4.3×4.5in).

Below: Plain weave in paper yarn. Warp and weft stitched through cardboard, so sample is integrated into the backing, 2024. 11.5×11.5cm (4.5×4.5in).

Chaos – Random Weave

In contrast to the regimented order of plain weave, random weave allows for the build-up of a surface where threads are travelling in many different directions. This technique originates in basket weaving and it allows great potential for three-dimensional structures and for working on a variety of scales. Certain materials lend themselves particularly well to random weave. Those with stiffness and body are especially good for more dimensional work (see Chapter 4, page 46, for more on random-weave vessels). Softer materials can also be effective, as long as they have some sort of tension or support, at least during construction, and possibly retained as part of the finished piece.

Whereas plain weave relies on a warp existing first, through which the weft can be taken, random weave is built up with multi-directional passing of the thread right from the start. A random-weave two-dimensional surface can be formed on a pin loom, and removed once complete, or on a frame that will remain part of the final structure. The key to building up an even and strong surface is to pass the thread under and over other threads as much as possible, changing direction frequently. Pulling back in the opposite direction after passing under a previous thread will help to increase tension and stability early on. The appearance of randomness actually comes from working in quite an ordered way, and you are aiming for threads travelling in as many different directions as possible, breaking any patterns of regularity as you weave.

Above: Stained blotter with random weave in paper yarn, 2023. Part of *Book Marks* series. 20×6cm (7.9×2.4in).

Opposite above: Beach twigs with random weave in hand processed and spun linen, 2018. 10×9×2cm (3.9×3.5×0.8in).

Opposite below: Random weave in paper yarn. Sample formed on pin loom, 2024. 7×7cm (2.8×2.8in).

31

Book Marks

A pile of rusting paperclips was the catalyst for this creative response, sparking conversation between the conservators at the Bodleian Libraries at Oxford University and myself as the artist. Inspired by marks left accidentally in books as well as the items deliberately placed to locate a page, this collection of bookmark-sized objects is the result. Although a variety of print techniques were used in some of this work, weave was also employed, and both plain weave and random weave were used in different parts of the project.

Clips marking and manipulating paper, inadvertently sculpting and re-forming the shape of a book; pins piercing a page; stains seeping from accidental spillages; objects left over time, leaving a ghostly print of their position; corners turned and edges scuffed; a treasured leaf, flower or feather pressed to mark a moment, leaving its own memorial on the page. These happenings were explored visually and materially, building up a small library of interactions with paper.

Woven paper was used to make a number of the pieces, some twisted into cordage before weaving onto a warp of commercial paper yarn, some cut into narrow strips and woven as it is, the pressure of beating the weave down compressing the paper into a solid surface.

Left: Stained blotter with random weave in paper yarn, 2023. Part of *Book Marks* series. 20×6cm (7.9×2.4in).

Above: Woven repurposed book page strips on paper yarn warp, 2023. Part of *Book Marks* series. 20×6cm (7.9×2.4in).

Middle: Cordage made from repurposed book pages, woven on paper yarn, 2023. Part of *Book Marks* series. 20×6cm (7.9×2.4in).

Below: Stitched wrapped twining in paper yarn with unfolded paperclips, rust and tannin staining, 2023. Part of *Book Marks* series. 20×6cm (7.9×2.4in).

One of the sculptural objects was made by taking a slice of a book, soaked with tea and using the paperclips removed (by the conservators) from the original inspiration to distort the shape of the pages and make rust marks. A band of woven paper string holds the pages in their newly sculpted form, made from repurposed book pages, hand-twisted into cordage.

Other pieces use stained blotters from the Bodleian Libraries conservation department, the shapes of the stains traced round with pin-pricked holes that were then woven through in a random-weave formation with fine paper yarn, making a three-dimensional form from each two-dimensional stain. The rigidity of paper yarn in this situation made a lace-like but very strong structure that extends organically from the paper surface.

Another sculptural *Book Mark* was made using paperclips removed from items in the Bodleian Libraries collection by the conservators. I embedded the rusting paperclips into a bookmark-shaped surface woven from paper yarn, a few on each pass of the weft. These built up to make a shaggy, brush-like surface, with the paperclips hanging or hinged from the woven structure (see image on page 97).

Below: Grouped *Book Marks*, 2023. Paper yarn, printmaking paper, paperclips, re-purposed book pages, feathers, leaves. Weave, cyanotype, collagraph, paper lithography, embossing, piercing, staining, stitching, botanical contact print, rust print.

Chapter 3

STITCHED WEAVE

Opposite: Stitched wrapped twining sample (detail), 2024. Paper yarn, re-purposed guitar string, leaf stems, pine needles, silk thread. 22×8cm (8.7×3.1in).

Darning

DARN
to mend a hole in cloth by interweaving yarn with a needle.

Darning has a practical history in domestic textiles, keeping items functional by mending holes and strengthening bare patches. In the past, both knitted and woven cloth would generally have been mended as discreetly as possible, the aim being for the mended area to blend in with the surrounding threads. Patching and repair have a place in many cultures, but traditionally may have carried with them the embarrassment of poverty – something to hide or to be ashamed of. In recent years, however, visible mending has become popular, where contrasting colours of thread are used to draw attention to the repair rather than hiding it. This can be a means for individuals to express creativity in their mending and exhibit their credentials as environmentally conscious consumers, as well as signalling their appreciation for hand-worked craft.

When darning a hole, a set of warp threads are stitched across the opening and anchored at either side in the stable cloth. These warp threads are then woven across with a set of weft threads, again anchored at either side. The hole is thus filled with a newly constructed patch of cloth that is integrated into the existing surface. It is easiest to work the weft element of a darn with a blunt needle, so as not to sew through the warp threads, but a sharp needle can be used by turning it to weave through with its blunter eye end.

Surface darning can be used in a decorative way, to add colour and detail to a cloth, or to add reinforcement to an area that is weakened by wear. A surface darn could be worked in a variety of shapes or densities of stitch. There is plenty of room for experimentation with different thread types, colour combinations and weave structures. Rather than just plain weave, more complicated designs can be introduced by varying the pattern of the surface weave.

Darning requires the cloth to be stretched and held under tension, so that the new stitches don't pull or pucker the base cloth. Traditionally, a darning mushroom would be used (this slips easily inside a sock that needs mending) and these come in a variety of different shapes and forms. The cloth can be held stretched over the mushroom while it is darned. Various tools are available to help form an even patch of surface darning. The samples shown here were worked using a tiny darning loom, a device that grips and stretches the base fabric and has little hooks for the warp threads (see page 38). The position of the hooks can be changed with each row of weaving to make a slight shed in the warp, and this speeds up the process and can give an even finish. However, a tool such as this can also introduce restrictions on the scale and shape of the darned patch. An embroidery hoop will also work well to stabilize the cloth while surface darning is being worked.

Opposite: Vintage Bakelite darning mushroom. 10×6×6cm (3.9×2.4×2.4in).

Below: Handmade wooden darning egg used by my grandmother. 9x5x5cm (3.5×2×2in).

Above: Small embroidery hoop used for stabilising fabric during darning. 11×12cm (4.3×4.7in).

Middle: Small darning loom used to make samples shown on facing page. 11×7cm (4.3×2.8in).

Below: Surface darning sample in naturally dyed silk thread on wool blanket, with embroidery hoop, 2024. 17×14cm (6.7×5.5in).

Three surface darning samples exploring variations in weave pattern and thread colour combinations. Naturally dyed silk thread on wool blanket, 2024. Each sample 3×4cm (1.2×1.6in).

Stitched Wrapped Twining

The wrapped twining technique appears in basket-making traditions from many parts of the world and I was introduced to it by the celebrated basket-maker, Mary Butcher. We explored the technique during a workshop in a basketry context, but I was immediately struck by its potential for use in a variety of situations and with different materials. As well as 'in the round' for vessels, I realized that this technique could be used on a flat warp. It will immediately introduce structure and strength when used with the right combination of materials, but also can be used with plenty of space between elements, allowing for grids and gaps in the structure.

The technique uses three elements: a set of 'warp' threads (or more rigid spines); a coiled (in three dimensions) or repeated element laid perpendicular to the first element; and a third, soft or flexible element, which is stitched between and round the other two, wrapping round them in turn and bringing the structure together.

Above: Stitched wrapped twining in progress. Linen warp stretched on frame, blackthorns, stitched wrapping in cordyline fibre, 2024. 10×9cm (3.9×3.5in).

I like using this technique to bring together rigid and soft materials. For example, I can stretch a warp of linen or paper thread onto a frame, giving me a taut base on which to work; I can then add rigid elements, such as stems or twigs, across the warp, and use a flexible thread or fibre (which could be the same fibre as the warp, or different) as the stitched twined element to join the other two together. The magic of this techniques lies in its potential to allow me to work with a mix of materials in quite an experimental way; for example, to incorporate rigid stems or other stiff elements, which would otherwise be quite difficult to weave into a structure (especially when working in a frame and therefore without much of a shed).

In a basketry or vessel situation worked in the round, this structure brings together twining with a coiled element, with the inside and outside of the vessel having different parts of that structure prominent. When worked flat onto a warp stretched on a frame, there is also a difference between the look and texture of the structure on the two sides: one side has the raised repetition of the stiff element, while the other side (which might be considered the back) has a more stitched appearance from the twined or wrapped element. As the surface is built up, the repetition of the stitched or wrapped element can provide a pleasingly dense surface.

Below: Diagram showing the three elements of stitched wrapped twining: vertical, horizontal and travelling stitched wrapping.

As well as enabling us to incorporate rigid materials into our weave structure, this technique can be incredibly useful when working with other unconventional weave materials, including fragile ones. During one particular project, I was invited to make work on a theme of 'moss'. Gathering a handful of dried moss, which the birds had already picked out from between the grass of a garden lawn, I started to experiment. By laying the fragile stems across a warp on my weaving frame, I found that I could stitch between the warp threads, gently securing the moss onto the paper warp. I built up a small surface of the moss stems, allowing their roots and tips to extend beyond the warp at either side. The delicate stems are supported by the warp and the stitched wrapped twining adds a visual rhythm, while securing the other elements together to create a stable structure.

Using the same technique, but this time working with rigid, sharp blackthorns (*Prunus spinosa*), I was able to build up a long strip, which, once completed, had three-dimensional

qualities, depending on how I arranged it (see the photograph on page 40). The thorns were gathered in winter, when the hedges are bare, and their silhouettes make dark shapes against the winter sky. The thorns were in great abundance, and I started gathering the long ones, adding a few to my pocket each time I walked the lanes. Back in the studio, I sorted through the materials I'd gathered, lining them up and grouping them by length. I often arrange materials or objects in this way as I sort, lining them up on the table to get to know their detail. Bringing them together in a woven structure that keeps these lines is the next step. Working onto a warp that was stretched across a frame in sections, I stitch-wrapped the thorns with the fibres of cabbage palm (*Cordyline australis*) gathered from suburban streets, leaving the ends of the fibres to hang loose to add another textural element to the piece. The thorn lengths were allowed to fluctuate along the line, building up a repetitive, strong structure. Once this strip was removed from the frame, the piece could bend and flow or be kept taut, allowing for experimentation in how the piece might be displayed.

Opposite: Moss Cloth Fragment, 2024. Paper yarn, plant-dyed silk/cotton thread, moss (gathered from domestic lawn). 8×15cm (3.1×5.9in).

Below: Moss Cloth Fragment, 2024. Showing the back of the weave with warp threads loose before finishing.

Another example of stitched wrapped twining, this time with sections of a large ornamental miscanthus (bamboo-like grass), gathered after the clumps had been winter pruned, shows the three-dimensional potential of the technique, even when constructed on a flat warp. The grass stems naturally from sections and, when cut, create beautiful smooth tubes with nodes where the sections meet. This slippery surface needed a firm stitched element to hold it tight. Using the same strong linen thread for both warp and stitched wrapping, the shiny tubes were held firmly in place. Once off the frame, the piece naturally wants to curl, revealing both the front and back of the stitched wrapping. The natural curl also has a desire to twist, with the repetitive stitched wrapping always moving in the same direction, so that a kind of bias is introduced.

Experimenting with a mix of materials, but using familiar techniques, forms a set of what I call 'material sketches'. Working in this way means I can try things out, testing how materials feel to work with and how they can come together in different combinations. Each experiment or material combination leads me on to other ideas and possibilities. The use of a technique that is simple and repetitive allows me to focus on learning how the materials perform, finding out what their boundaries are and where their strengths lie.

Below: Stitched wrapped twining in linen with miscanthus stem sections, 2024. 20×12×7cm (7.9×4.7×2.8in).

Opposite: Stitched wrapped twinging sample on linen warp with apple wood, blackthorns and stitched wrapping in cordyline fibre, 2024. 18×39×4cm (7.1×15.4×1.6in).

45

Chapter 4
DIMENSIONAL WEAVE

Opposite: Bean stems with flax (detail), 2023. Dried runner bean stems with twining in hand processed allotment-grown flax. 25×28×6cm (9.8×11×2.4in).

Taking Form

'Basketry is, basically, an artefact construction technique in which strands of fibres of various types are interwoven.' [9]

There are obvious links between the weaving of cloth and the weaving of baskets, and often the same techniques are used in both traditions, even if they are known by different names. The choice or availability of material is probably the biggest factor in defining whether a woven structure might become cloth or something more rigid and vessel-like. Whereas weaving cloth generally makes use of continuous, flexible yarns, basketry or the weaving of vessels will often use shorter lengths and less flexible materials, resulting in what might be referred to as 'hard textiles'[10].

Whereas the weaving of cloth generally needs a loom or some sort of equipment, however basic, to hold the warp under tension, the weaving of three-dimensional forms will usually require at least some of the material to have a certain amount of rigidity in order to hold the shape that is being formed.

'The basket's three-dimensional form develops in the making, acting as both the technology – the loom or frame on which the basket is made – and, at the same time, forming the structure of the basket itself.' [11]

Understanding the potential of whatever material is available is the key to making a woven structure on three dimensions. The best way to understand a material is to work with it: try things out, experiment – learn by physically engaging with it and come to an understanding of what its boundaries are. Having practical knowledge of one material might lead you to make presumptions about similar materials, but you can only really know the detail of each type of material and how it acts in your hands by working with it. In the past, the weaving of baskets would have been purely about function. In contemporary basketry, coupled with increasing environmental awareness, there is 'space for the non-functional basket, of which the purpose is often solely to explore materials'[12].

'In general, the relationship between maker and basketry material is not one of imposing form onto substance or making it do what one wants, but rather of knowing the life cycle, habitat and potential of the material and listening to the wisdom that it may impart.' [13]

The separation and overlapping of techniques are recognised by Mary Butcher in her description of examining and reclassifying baskets and basketry in the Pitt Rivers Museum collection (part of Oxford University):

'For some, a basket was a container and for others it was not, although it might enclose space; for all it was a woven structure, perhaps three-dimensional, using natural or synthetic materials, sometimes rigid or semi-rigid, sometimes functional, sometimes decorative. All were clear about the existence of special weaving techniques, though these might overlap with practices in other crafts.' [14]

Opposite: Stitched wrapped twining three-dimensional vessel, 2024. Paper yarn with naturally dyed silk/cotton thread.

Curved Stems

Weave can be used as a means of joining materials with a three-dimensional aspect, even if the woven element of the structure is no different from how one might join a series of flat warps. Runner-bean stems were left at the end of the growing season to dry out, still wrapped around their cane supports on the allotment. The stems in their dried state had retained the twisted form; they were surprisingly strong and lent themselves to some experimentation with different joining techniques. One set was used to construct an experimental cube, using individual dandelion stems twisted into short pieces of cordage – a set of natural cable ties. These short dandelion strings were used to bind the bean stems at various meeting points so that a lace-like cube was built up. In a different configuration, more of the bean stems were joined at their meeting points, this time with sections of dense weaving with my allotment-grown, handspun flax (linen).

Another group of materials left over from allotment growing, which otherwise might be left to compost or rot down after the growing season, are the pruned stems from my fruit trees. Each winter the trees are pruned to keep the height manageable

and the shape of the trees healthy and productive. I have taken to saving some of the thin whippy stems each year, placing them while still freshly cut and flexible in various repurposed containers, including large plant pots and an old metal barrel that I found in the hedge when I took the plot on. Left in these containers while they dry out, these stems take on the curved forms that they are subjected to. I can then use them in their curved state as a three-dimensional warp. I particularly like to use dried bindweed (*Calystegia sepium*) stems to twine between the curved apple-wood stems, joining each one to the next and building up a sculptural curved surface. The combination of bindweed stems with the apple-wood curves works, as the two materials have a balance in their respective strengths. Perhaps it is also significant that the bindweed finds its way into the apple trees if I don't keep on top of it in the growth spurt of mid-summer, quickly winding its way along the branches and establishing its tenacious presence with alarming speed.

Above: Arc ii & Arc iii, 2024. Apple wood, twining in bindweed. 35×15×20cm (13.8×5.9×7.9in).

Below: Apple wood pruned from allotment apple trees, dried inside barrel to create curved stems.

Opposite above: Runner bean stems with dandelion cordage cube, 2021. Dried stems, dried dandelion stem cordage, acrylic cube. 10×10×10cm (3.9×3.9×3.9in).

Opposite below: Bean stems with flax, 2023. Dried runner bean stems with twining in hand processed allotment-grown flax. 25×28×6cm (9.8×11×2.4in).

2D to 3D

There are some cases where a woven surface might be constructed as a flat, two-dimensional surface and then formed or manipulated to create a three-dimensional piece. One example of this approach is a pocket woven to fit a stone gathered on a walk. The soft linen pocket was created by weaving on a frame, after I had first worked out the shape needed to fit this particular pebble (top right). Once woven, it was cut from the frame and folded round the pebble, and the remaining warp threads were stitched into the opposite side, bringing the two sides together to form a bespoke pocket.

Similarly, a woven flax (linen) vessel was formed round an egg as part of the *Clutch* series, weaving three sections flat on a frame and then bringing them together around the egg, forming a protective second layer over the fragile shell (centre right).

Working onto a former of some sort can be useful, particularly when starting a weave in three dimensions. A pebble, small bowl or wooden shape might be ideal. I have various wooden egg shapes that give a solid base around which some tension can be maintained while weaving, although I will usually reach a point when the former can be removed, either because the structure is strong enough to support itself, or I've reached the point where the former will become trapped if I weave any further around it. Of course, this trapping might be intentional, in which case I will continue weaving as long as I want and leave the former as an integral part of the finished piece.

Above: Clutch vessel #11 in progress, 2022. Allotment grown and hand processed flax on linen warp. 5×7cm (2×2.8in).

Opposite above: Wrapped Pebble, 2016. Weave in linen, pebble. 5.5×4×2.5cm (2.2×1.6×1in).

Opposite middle: Clutch vessel #11, 2022. Woven allotment grown and hand processed flax on linen warp, hen's eggshell. Part of *Clutch* series. 5×5×5cm (2×2×2in).

Opposite below: Dandelion Weave with Stone, 2023. Dandelion stem cordage, woven in one continuous warp/weft structure, formed into pocket with stone. 15×8×6cm (5.9×3.1×2.4in).

53

Weaving pockets

Another type of former can be made from a piece of thick card. Wrapping the weaving material round the card in one direction, having anchored it at the bottom corner with a pin, creates a warp through which the same continuous piece of cordage or thread can be woven. It is important to keep weaving round the bottom of the card and up the other side, turning each time the top warp thread is reached. Once the weaving reaches completion, if the turn from warp to weft was made at the correct position (i.e. the opposite corner to the starting point), then the thread will start and finish at the same point for a nearly invisible join.

The same principle applies to random weave (also see Random Weave Vessels and Forms, page 59). Three sides of a piece of card can be worked over and around, ensuring even coverage and a build-up of strength, with plenty of weaving under and frequent changes of direction, as in the example below right.

Woven bases

There are various different ways of forming the base for a three-dimensional form, but where to start? There is a convention within some types of basketry to create a base that stabilizes the structure while providing a set of spokes (warps) around which more material can be woven or twined, and this could be formed in one of the following ways:

- By weaving a set of perpendicular elements to create a square, around which the spokes will bend upwards at the point of weaving; this can be woven using a plain weave or hopsack configuration, for example.
- By twining two sets of spokes/warps in the middle of their length, which are then overlaid to form a cross; the spokes can then be woven around, bringing the two sections together into a double-layered base.
- By using a set of radials to form a circle, overlapping them in the middle; weaving starts a little way out from the centre, to allow for the bulk of the crossing point.
- By coiling one material and using a second to stitch around the coil, to join each layer to the previous one, either wrapping the core entirely or spacing the stitches out as the structure grows.

Opposite above: Plain weave woven pocket, 2024. Paper yarn, woven on a card former. 6×5×3cm (2.4×2×1.2in).

Opposite below: Random weave pocket, 2024. Paper yarn, woven on a card former. 6×5×3.5cm (2.4×2×1.4in).

Clockwise from above left:

Coiled vessel base, 2024. Flax stems, stitched with flax fibres. 7×7×3cm (2.8×2.8×1.2in).

Vessel for a stone – Bindweed, 2023. Coiled bindweed stems, stitched with bindweed stems. 11×9×6cm (4.3×3.5×2.4in).

Woven vessel base, 2022. Dandelion stem woven base, with twined sides in hand processed linen. 4×4×3cm (1.6×1.6×1.2in).

Woven vessel base, 2024. Jute, woven base with twined sides. 7×7×4cm (2.8×2.8×1.6in).

Clockwise from above left:

Woven vessel base, 2022. Sweetcorn husk. 8×5×5cm (3.1×2×2in).

Crossover twined vessel base. Paper yarn. 11×5×5cm (4.3×2×2in).

Radial vessel base, 2024. Paper yarn with twining in spun nettle fibre. 3×5×5cm (1.2×2×2in).

Multiple strand woven vessel base, 2024. Paper yarn with stitched wrapped twining in silk/cotton thread. 12×7×7cm (4.7×2.8×2.8in).

Clutch

This series was created for the 50th anniversary exhibition of the Textile Study Group in 2023. The theme of 50 was interpreted, in my case, by making 50 different items, each one a variation on a theme. I had been exploring ideas around nests, nesting and eggs as an initial starting point, using 50 as the number of objects in the series. Working with only materials sourced from my allotment alongside eggs from the kitchen, I used the boundaries of this small scale to experiment with a range of soft and rigid materials. Each vessel uses a combination of technique and/or material that is different from the rest. The natural strength of a complete egg allows for material to be worked around it, supporting soft material until it forms a nest-like structure. Once the textile element is completed the egg can be partially broken and the liquid inside removed, leaving the fragile shell in place to support the soft materials. More rigid materials can support themselves and I used these to create shell or nest-like vessels. The materials I used for the series of variations included eggshell, flax, nettle, bramble, dandelion stem, bindweed stem, soft rush, sweetcorn husk, ceramic, newspaper, garlic leaf and daffodil leaf.

This series gave me an opportunity to play with small quantities of material, each of which I may have had only a small amount of as they were all sourced from my allotment, to explore various ways of forming small vessels, working with technique and material interchangeably. For the techniques and materials used, see Appendix: *Clutch* materials and techniques, page 122.

Above: Clutch, 2023. 48 of a series of 50 vessels formed around hens' eggs using allotment sourced materials. See Appendix for full list of materials and processes. 81×35×7cm (31.9×13.8×2.8in).

Random Weave Vessels and Forms

Random weave – the interlacing of long materials in an apparently random fashion and without a formal arrangement of knots or loops – lends itself well to three-dimensional work (see also Chaos – Random Weave in Chapter 2, page 30).

Working onto some sort of former can be helpful, at least for the start of the structure, until there is enough of a network built up to be self-supporting. A former could be a found object, such as a stone or another vessel, or it can be made specifically to the dimensions you want to work to. A plastic bag filled with rice or similar, taped up to make a tight and solid form, is ideal. This can be woven round and then, when you want to take out the former, the plastic can be cut with scissors or a sharp knife through a gap in the weave, the rice poured out and the plastic bag removed. The hardest part is the getting started. Wrapping your thread round your chosen former a few times and holding the start of the thread tightly in place, start to weave the thread under other threads as soon as possible. Change the direction of the wrapping, weaving under as you go; pull back against other threads to change course as you weave, which will help to build up a strong structure. Just keep going – it will take time to build up an even weave.

Removing a rice-filled former from your structure will leave you with an open or hollow vessel, as long as the weaving material has some stiffness to it. Paper yarn, cordage and some stronger plant material, such as bindweed (*Calystegia sepium*) stems, all have enough rigidity to hold firm once a certain amount of random weave is built up. Working with softer threads may require the former to remain in place and this could also be an important part of the finished piece. In my *Clutch* series of 50 vessels, I worked onto whole hens' eggs and many of the eggshells remained in place after weaving. The vessels were constructed when the eggs were whole and once weaving was complete, the shell was broken carefully so that the liquid part of the egg could be removed or blown out, leaving the rest of the shell in place to support soft materials.

Left: Random weave vessel, 2024. Paper yarn. 8×8×4cm (3.1×3.1×1.6in).

Right: Clutch #24, 2023. Random weave, daffodil leaf, eggshell. 6×5×5cm (2.4×2×2in).

Braids and Strips

A braid (or plait) is formed from several strands of material into a strip of varying length. A 'self-weft' structure, each strand in turn weaves over and under the other strands, where each strand works as a weft then returns to the warp. Think of a three-strand plait as the simplest version of this. By increasing the number of strands, the width of the strip also increases; however, the more strands included, the more complicated it is to hold and keep track of. I find that nine or 11 strands is satisfying in width, but any more would be tricky to handle. I prefer to work this structure in a chevron formation, working from each edge into the middle.

Even a three-stranded braid, such as many of us may have formed in our own or another's hair, can provide a strip that can be formed into a coiled vessel, or stitched together to create a kind of strip cloth.

Narrow bands of woven cloth are embedded in many ethnic textile traditions, often because a strip can be woven on a basic backstrap or other simple loom set-up. These strips can then be joined together to make a cloth of the desired dimension, as shown left. This principle can be applied to all sorts of different materials and on a range of scales. The potential to form a strip or a set of strips into a dimensional structure can lead to many possible outcomes.

Opposite: Daffodil Strip Cloth, 2023. Woven daffodil leaf on spun nettle fibre warp, strips joined with daffodil leaf stitch. 16×16cm (6.3×6.3in).

Below left: Clutch #41, 2023. Braided garlic leaf, coiled, stitched with hand spun flax, eggshell. 6×5×5cm (2.4×2×2in).

Below right: Clutch #33, 2023. Woven daffodil leaf on flax warp, coiled. 5×5×5cm (2×2×2in).

Frames and Objects

Found frames

Much of the weave featured in this book has been woven on some sort of frame – either with pins hammered in or with the warp wrapped round the whole frame and brought together in a tapestry-weaving style. It is very easy to repurpose frames for weaving, from large wooden picture frames to smaller objects for more intimate pieces. Using found objects as frames to work onto can add another dimension to the work, perhaps giving a playful element or referencing a place or time. Allowing the weave to remain on the frame, to become part of its finished state and structure, retains any such reference and meaning as part of the work, and often the work can be presented simply as it is, keeping the structure under tension and removing any need to mount the work in any other way. There is an honesty to presenting work in this way – it reveals the process by which it has been made and provides a context that remains present.

Left: Wrapped Book, 2024. Old dictionary with weave in plant dyed silk/cotton thread. 13×9×3cm (5.1×3.5×1.2in).

Right: Bird Feeder with Weave, 2018. Found bird feeder with weave in silk thread. 32×9×9cm (12.6×3.5×3.5in).

The String Drawer

I grew up in a household with a make-do-and-mend attitude, where leftover things were often saved in case they would come in useful. We had a section in a small chest of drawers where pieces of string were kept, along with other useful items. Each piece of string had been judged long enough to use for a variety of potential tasks and therefore worthy of keeping individually in a neat little butterfly bundle.

An old wooden picture frame with its contents removed sparked a starting point for a piece of weaving (see page 64). Looking through the threads suitable to use for a warp on this modest-sized frame, I found a bundle of warp threads left over from another weaver's project, which I had been given a number of years before in case I could make use of them. Some of these threads were just about the right length to form a set of warps on the picture frame. I applied each length to the frame by doubling it over at the top, looping it through itself, stretching the ends down to the bottom of the frame and tying them round themselves. Each length thus formed a pair of warp threads sitting across the front of the frame. I like to warp up a frame in this way, especially if I'm working on a small scale. A set of tensioning threads were taken across the bottom of the frame, attached to each side of the frame and woven through the warp threads, to tension and space them out evenly. A row of double knots was worked round each warp thread at the base, giving a defined start to the weaving. Although this piece was not intended to be removed from the frame, this row of knots is a conventional way to start tapestry weaving, forming a firm beginning to a woven piece.

On a visit to my dad's house, I looked in the little chest of drawers and found that the string collection was still there – perhaps some of those pieces of string have been there longer than I've been alive! Dad was keen that they should be used, so a handful came back to the studio. They are now woven into *The String Drawer*, a piece that celebrates the string drawer and domestic leftovers, the attitude of making use and minimizing waste – the frame, warp and weft all repurposed from their original use.

Below: Wooden box with collected string fragments. 20×13×9cm (7.9×5.1×3.5in).

64

Weaving with a selection of threads that vary significantly in thickness, texture, softness and length means that the resulting woven surface of *The String Drawer* is uneven. Setting the warp up with relatively narrow warp threads and with close spacing lends itself to weaving with narrow threads. Some of the pieces of string were much thicker, stiffer or softer than others, so each one behaves differently on the same warp. This is an interesting exercise in itself – seeing how the varying weft sits within the warp, whether it can be beaten down to cover it or not. I like the serendipity of this approach and the variation in the surface as each new piece of string is introduced. There is an honesty to weaving like this, with humble repurposed materials, the ends of the string exposed on the front of the weave, including knots if they were present in the string.

However, there was still more string, and a curiosity in me to see how each different length with its different qualities would act as part of a woven structure. So I took another repurposed object, this time a wooden box that had previously held chocolates (and had already been through a couple of reincarnations for different uses), and I drilled tiny holes in each end, so I could thread a warp through but so that the lid would still close. This warp was set further apart than the first, so could accommodate some of the thicker string lengths. I carried on weaving, taking a string from the pile without worrying too much how it would weave, to create *The String Drawer II*. There are more wooden picture frames sitting waiting, so this may well become a series, perhaps until that drawer is empty of random pieces of string.

Opposite above: The String Drawer, 2024. Repurposed picture frame, re-used cotton warp, woven string fragments. 29×21cm (11.4×8.3in).

Opposite below: String bundles from the string drawer collection.

Below: The String Drawer ii, 2024. Repurposed wooden box, plant dyed silk/cotton warp with woven string fragments. 25×21×3cm (9.8×8.3×1.2in).

Slideshow

When I was a child, the family photographs were made into slides that could be shown with a projector; and at family gatherings, we might set up the projector and screen in the living room and select a few boxes of slides to look through together. Inevitably, some of the photos that were taken were not as good as others, and there was a certain amount of repetition. During a clear-out I was offered some of these duplicate (or boring) slides, in case I might be able to use them. They are made of tiny frames of card, which hold the slide transparency; and some of the cardboard frames are held within a pair of clear-plastic covers, which clip together at the corners, so those cardboard frames have their corners removed. Some of the slides have numbers handwritten on, while others might have an arrow or instruction to place the slide in a certain way to ensure the image is viewed the right way up. There is a nostalgia attached to items such as these, which are pretty much obsolete and more of a curiosity than anything else. When I first started doing talks to groups as part of my first professional role, I would make a selection of slides, carefully placing them into special holders, which were fed into the projector. Soon after, digital projectors became the norm, and now a talk and 'slideshow' is created on, and delivered from, a laptop.

I removed the unwanted transparencies from the little cardboard frames, having undone the plastic covers. In order to weave into the frames, I made rows of holes by pushing a pin through the cardboard. This allowed me to stitch a warp into the frames, on which I could then weave my weft. Some of the slides were given holes down the sides of the aperture as well, allowing the weft to be taken right through the frame at intervals. By playing with combinations of thread colour and density of weave, there are many possibilities that could be tried. I chose colours from my collection of plant-dyed threads, most of which have been dyed with various plants from my allotment. This colour palette always sits well together, with the hues complementing each other no matter what the combination.

Working on a small scale such as this allows for experimentation and variation. As small items are relatively quick to complete, a combination of threads or pattern can be tried and completed, and then another variation started relatively quickly. I like this build-up of small units, a collection of items that can grow to become a group. They can be moved around, places switched, and different combinations tried out. There is a playfulness to this way of working, as well as a practicality and portability.

Opposite: A quartet of woven slides, 2024. Re-purposed cardboard slide frames, plastic slide casings, weave in plant-dyed silk/cotton thread. Each slide 5×5cm (2×2in).

67

In the Round

Circular objects also present possibilities as frames for weaving. These could include found circles or hoops formed from flexible materials. By taking as your inspiration the Dorset button – a traditional embroidered button made with a set of stitches on a horn or metal starting ring – it is possible to create a set of warps that cross in the middle (like the spokes of a wheel) and that can be woven between. This could be worked on a variety of scales and with many different materials.

A warp can be created on a hoop in a number of ways. It may be useful to work a set of blanket stitches round the circle to give something to anchor crossing warp threads to. Depending on the material of the hoop, and if not too slippery, a warp might be wrapped, crossing in the middle. Some materials might lend themselves to making small holes around the hoop for anchoring the warps.

I have stitched into limpet shells (*Patella vulgata*) using a drilled-hole technique for a number of years. The first group of these came from a beach in North Wales and were exhibited as part of *Findings* in 2016. I was fascinated by the number of these cone-like shells that had lost their peak – presumably bashed about and worn by the action of the sea. Limpet shells are very hard and much less fragile than many other shells we might find washed up on a beach. Finding a way to drill tiny holes into the shells meant that I could stitch a circular warp into them and then needle weave in a concentric circular route. These shells continue to intrigue me and when I find suitably damaged ones on beach walks, I collect them to stitch and weave into in this way.

It is possible to create a pin loom with a circular arrangement of pins or nails, rather than the square or rectangle that we've looked at in other examples. This could be worked across the middle and then in a concentric weave, as with the limpets. In order for a concentric weave to work, there must be an odd number of spokes to the wheel-like warp. Alternatively, the pins can be woven into in a more conventional warp/weft arrangement, as in the example above, but with the shape of the overall piece being dictated by the placement of the nails.

Above: Pin loom with weaving in progress, 2024. Wood, panel pins, paper yarn. 20×11×4cm (7.9×4.3×1.6in).

Opposite above: Stitched limpet, 2024. Broken limpet shell (*Patella vulgata*) with drilled holes, circular needle weaving in silk/cotton thread. 5×4×1cm (2×1.6×0.4in).

Opposite middle: Random weave in hoop, 2024. Wooden ring, blanket stitch and random weave in paper yarn. 10×10×1cm (3.9×3.9×0.4in).

Opposite bottom: Stitched limpet, 2024. Broken limpet shell (*Patella vulgata*), blanket stitch and circular weave in paper yarn. 5×4×1cm (2×1.6×0.4in).

69

WILD WEAVERS
Ann B. Coddington

Ann B. Coddington is an artist based in Illinois, USA. At the centre of Ann's practice is her intimate knowledge of fibre materials and the history, memory, fragility and strength that they each possess. Their means of construction are ever-present reminders that we are seeing a handmade thing that draws us back to the familiar experience of holding a crafted vessel. Ann's work is tethered to a domestic past, recalling shapes that allude to the feminine body. These woven basket structures speak to our inchoate need to contain and carry what we value most.

Ann works primarily with an off-loom weaving technique called twining that gives her the ability to shape lightweight yet rigid structures that exhibit the physical qualities of handmade objects, while also speaking to our contemporary embodied experiences of growth, decay, attachment and separation. She has greatly expanded what is possible with twining by developing novel ways to curve, split and join her sculptures into compelling biomorphic forms. Although twining is the basis for much of her work, she also at times incorporates other fibre techniques, such as looping, coiling, lashing, netting and crocheting.

She explores new ideas at the start of each studio day by drawing out sculptural shapes in her pocket-sized sketchbooks. The shapes first come intuitively; eventually, a feeling or an experience coalesces through the way the imagined forms enclose a space, or divide and rejoin, expand or narrow in on themselves. Ann also often presents collections of smaller sculptures with contrasting fibre techniques to create a whole constellation of objects that speak to the experience of being in a family or larger community. Made mostly from linen fibres from our natural environment, these sculptures are fashioned by her through ancient processes to embody the visceral knowledge of being in the world.

Opposite: Maiden, 2024. Twined waxed linen and four strand braid. 100×25×15cm (39.4×9.8×5.9in).

Below: Imminent (detail), 2020. Twined waxed linen and hand knotted netting. 30×20×20cm (11.8×7.9×7.9in).

WILD WEAVERS
Jane Walkley

Jane Walkley is a UK-based artist who explores the complex relationship between memory, place and attachment. Her work focuses on industrial heritage sites in the north of England: Sunny Bank Mills, a former textile mill; and William Lane Foundry Ltd, owned by her family from 1862 to 1984. By researching the history of these sites and involving the community, she gains an understanding of how these places, and the relationships people have with them, have changed over time, particularly when the buildings have been repurposed or demolished.

Jane uses traditional tapestry, mould-making and casting techniques to create tactile, sculptural textile pieces that maintain a physical and visual connection to these industrial settings. By incorporating materials directly sourced from the sites, such as mill debris, dust and metal shavings, she creates a tangible link to the past.

She begins by creating hundreds of clay impressions of artifacts found on site, such as cogs, pegs and lags from industrial Hattersley looms, as well as her inherited foundry tools. These impressions are then used to create moulds for resin casts. The resin is poured into the moulds, cured, demoulded and finished before being woven into her warp on an upright loom. By incorporating materials such as dust and debris from these industrial settings, the cast objects become more than mere representations; they provide a physical and material link to our industrial heritage.

Traditionally, tapestries were hung on walls. Jane, however, challenges this convention by allowing the weight of her tapestries to dictate whether they are hung or laid on the floor, letting gravity shape their form. The long, exposed warps allude to the various stages of the textile-mill processes, from carding and spinning to weaving and finishing. This unfinished quality connects the work to the industrial past, highlighting the labour-intensive nature of textile production.

Opposite: Peg Plan Study iv, 2023. Cotton, worsted wool, jesmonite, mill debris, on cotton warp. 47×16×3cm (18.5×6.3×1.2in).

Below: Rhythm of the Weave iii, 2022 (reworked 2024). 1708 hand cast jesmonite mechanical parts (washers) from the Hattersley Industrial Loom, textile mill debris, worsted wool, on cotton warp.

WILD WEAVERS
Sarah Ward Podlesny

Sarah Ward Podlesny, founder of Lark & Bower, is a UK-based artist, weaver and tutor, working primarily with industry waste yarn and found objects. As a climate and environmental activist, the main focus of her work is to share knowledge through craft. She uses her woven work to advocate weaving as an art form in its own right, but also to raise awareness about waste, and the textile industry's impact on our planet and its inhabitants.

For many years up until the pandemic, Sarah was self-employed as a designer, working independently with brands and manufacturers to develop their woven fabric ideas. When the pandemic hit, however, she found herself with no access to her studio or her loom. After a while, her idle hands restless to be making again, it occurred to her that weaving wasn't just her job, but also a daily therapy and a way of life. So she started using bits of leftover yarn, little pieces of cardboard and a needle and thread to make small studies of her favourite woven structures – twills, herringbones, hopsacks and houndstooths. The process provided welcome moments of calm amidst the chaos and uncertainty of Covid-19.

Opposite: 'Held', West Runton Beach, Norfolk, 2022. (Unknown) Rock & cotton cord, wound and woven by hand using needle and thread. 13×8cm (5.1×3.1in).

Below: 'Roof Tile' East Beach, Southend-on-Sea, 2022. Sea eroded roof tile, cotton cord, wound and woven by hand using needle and thread. 12×10cm (4.7×3.9in).

Sarah can often be found scavenging for the perfect rock, slate, brick or broken tile, or even household waste, such as drink cartons, old books or cassette-tape covers, as a base to weave around.

While making, she often finds herself wondering: why isn't *weave* more celebrated as an art form? Why is cloth predominantly associated with industry, fashion, product and trends? Why is hand weaving regarded as a hobby? Why does cloth, or indeed the act of weaving itself, need to be validated by its function? Why does it feel so satisfying to make these woven pieces?

Perhaps simply joy is validation enough: making, reconnecting our hands with material, place and community, provides us with a feeling of both belonging and individual self-expression. To be weaving or engaging in any craft is to be partaking in an age-old and ongoing conversation between the past, present and future. As an ancient craft, weaving is deeply connected to what it is to be a human. As with music, weaving developed in many parts of the world simultaneously, long before civilizations had communication with one another – an idea often forgotten in our new digital and industrial world.

WILD WEAVERS
Jill Walker

Jill Walker is a UK-based artist who is fascinated by the way memories of time and place are revealed through intuitive acts of making. She uses her collection of found materials – vintage finds, old photographs, leaves, seeds, grasses – to create poetic artworks in response to a sense of place and her love of folk tradition and rural histories. Jill describes the way an empty container, trinket box, tin or frame draws her in with 'echoes of forgotten narratives'. She describes how 'these objects, rich with unknown origins and lost meanings, hold the memory of being once cherished and act as vessels around which to weave new memories of a moment in time'.

In Jill's studio, both made and collected items are curated on walls and tabletops, reminiscent of the museum collections that inspire her. Spending time arranging her materials reveals new associations, both visual and metaphorical. With fragments of tapestry and bunches of grass lying among metal and wooden finds, she reflects how 'it was a natural step to begin weaving grasses directly onto the objects, as if nature were entangling itself amongst the lost and found'. The visual dissonance this brings invites curiosity, bringing the viewer in for a closer look, and allows new narratives to emerge.

The installation *Daffodils and Meadow Grass* (2023) was inspired by the taxonomical collection at the Grosvenor Museum in her local city of Chester, with its archive of pressed flowers and butterflies. Created as a series of individual tapestries, the work expresses Jill's connection to nature while honouring the museum's reverence for its preserved objects. 'I sourced an old picture frame and began weaving intuitively, binding long grasses tightly within the tapestry. It was important to give space for each leaf while allowing the leaves collectively to embody their wild, free-flowing nature', she explains. In one tapestry, a butterfly wing is delicately woven into the empty space of a black lacquered box, reminiscent of a Victorian vitrine. 'I wanted to create a contrast across the tapestries,' she continues, 'from the pictorial delicacy of a butterfly wing to the sensorial experience of gathering meadow grass.'

Jill begins with play and close observation, following the plant's character, sensing its fragility and pliability – making slow repetitive gestures, knotting, binding and intertwining, setting limitations and remaining open to chance. Often left unfinished, the viewer is invited in to imagine the maker's hand completing the work, still open to interpretation and potential. The domestic scale and repurposed nature of her work create a singular familiarity – pieces that feel both common and deeply personal. Her aim is to create a space where personal and social histories intertwine, evoking memories that might otherwise fade, blending nature's marks with the story of place.

Opposite: Daffodils and Meadow grass (detail of installation), 2023. Tapestry. Found object, linen yarn, grasses. 70×33×21cm (27.6×13×8.3in).

Below: Daffodils and Meadow grass (detail of installation), 2023. Tapestry: Found object, linen yarn, silk threads dyed with daffodil petals. 25×24×4cm (9.8×9.4×1.6in).

77

Chapter 5
EPHEMERAL

Opposite: Hazel Weave Material Sketch (detail), 2024. Stitched wrapped twining, hazel twigs, cordyline fibre, linen warp. 26×16×4cm (10.2×6.3×1.6in).

Circular Thoughts

I have often thought that it might be interesting to make more ephemeral work. This originates from various ideas I have had about placing objects I've made on my allotment, to see how they interact with the place, changing over time with the action of the elements. Although I've experimented in small ways with this concept, the reality is that my work is very time consuming to make and so it is difficult to allow myself to let go of it in this way.

I have always admired the work of 'land artists', where the making of ephemeral works is often a focus and the recording of the piece (and its inevitable breaking down) through drawing, photography or film becomes an artwork in its own right. The sourcing of my materials is already influenced by the desire to work with as small an environmental footprint as possible. Perhaps working more ephemerally could aid an even lighter touch. So often, however, the practicalities of making work for exhibition and hopefully for sale (thus providing essential income) can get in the way of this more transient approach.

If an object is formed, reaching a point of completion, and then is exposed to the elements, allowing it to break down where it was made, to return entirely to the earth, it is part of a truly circular practice. Maybe we could learn to let go and appreciate all stages of the process. We are driven to keep what we make, to ensure it lasts. Is it possible to see the breakdown of something we've created as a positive process, to celebrate it even...?

Below: Miscanthus Weave Material Sketch, 2024. Twining in linen with miscanthus stems, apple twig. 30×26×10cm (11.8×10.2×3.9in).

Practical Considerations

I am often asked about the lifespan of my work. Because I'm using plant fibres, which naturally break down, there is an assumption that this process will happen rapidly and that my work will not stay the same for long. There is a misconception that work made with natural materials is inherently ephemeral, but this is not necessarily the case. Natural fibres kept in a damp atmosphere, or repeatedly allowed to get wet, will weaken and break down relatively quickly, as bacteria and mould take hold in moist conditions. However, if the fibres and structures are kept dry, there is no reason why they shouldn't remain stable for a very long time. Daylight can also play a part in weakening or fading. For this reason, it is advisable to display work out of direct sunlight, just as you would with an artwork such as a watercolour painting.

The fibres that I choose to work with and have access to, either on my allotment or via foraging, will all break down relatively quickly if left unharvested. The dandelion stems or daffodil leaves will quickly be broken down and disappear back into the ground if I don't gather them at the optimum time. Similarly, the bindweed (*Calystegia sepium*) in the hedge that I don't harvest, by winter will be breaking down and will be much weakened by the time the next year's growth takes over in the spring. By carefully choosing when to gather, then how to process and store these plants, I am interrupting that natural cycle of growth and decay, and I can then use the fibres to create my work. If these are destined to be hung on a wall, displayed as artworks or used as reference or teaching samples, I need to keep them in a stable state to be sure that I can confidently pass them on to a paying customer.

Sometimes it is good to work in a more experimental way, not worrying about the destination of the piece or its longevity after completion. Working with curved bean stems and individual dandelion stem 'cable ties' (see Chapter 4: Curved Stems, page 50), I made a structure that remained in the shed at the allotment. Over time it has weakened and broken down and become partially filled in by the weaving of spiders. The remains of it still hang there, almost indistinguishable from the vine stems growing into the shed and the other gathered materials hanging alongside it.

The inevitability of natural materials breaking down and changing does make them ideal for work that is more ephemeral, particularly when you wish to leave it open to the elements, allowing and accepting that change. Placing work made for the outside and observing the changes it goes through, perhaps even documenting that transformation, can be an interesting process and a justifiable end in itself. Of course, it is important to consider where work might be placed: in a garden setting or a relatively private place, where you have permission to do so, this is a matter of choice. When leaving structures in public areas, while it might be assumed that others could gain something from coming across and engaging with them, it is important to consider whether there are circumstances in which your work might be considered as littering. Hopefully, with natural materials this shouldn't be an issue.

Making work spontaneously with whatever is at hand can really lend itself to a more ephemeral approach. The classic example might be the daisy chain – who hasn't sat on a lawn and picked the daisies, and fashioned a simple chain by pushing a thumbnail through the stalk just below the flower, threading each one through the next to make a continuous thread? While this approach might make it more difficult to produce work that is as resolved or as refined as that made in the studio, there is scope for creativity and playfulness in responding to what is available in the 'here and now'. Potential situations for making ephemeral work include:

- Spending time in a place, and setting a personal challenge to make work with only what is available to forage on site.
- Creating work that is intended to be placed or displayed in a particular location as a creative/decorative act.
- Making work that will be allowed to break down with the action of the elements and observing or documenting the process.

Opposite: Experimental Structure (detail), 2020. Photographed in allotment shed 2024.

Below: Experimental structure, 2020. Bramble stem, runner bean stems, dandelion stem cordage. Approximately 50×50×30cm (19.7×19.7×11.8in).

Weaving Autumn

Away from home for a few days and staying in an unfamiliar place, I set myself the challenge of making ephemeral work with whatever was to hand on location. The coastal locale meant that beachcombing was an obvious starting point. After visiting a few different beaches locally, it became clear that some had more debris than others. The first had plenty of natural material that had been blown about or washed up by the sea, including seaweed and dislodged marram-grass stems. Mixed up with this kind of beach detritus were plastics, bits of rope or human rubbish. I have often collected this non-natural material from beaches, either keeping it to make work with, or simply taking it to a bin where it will enter the waste-management system rather than being tossed about by wave and weather, degrading into ever-decreasing fragments of plastic. On this occasion, however, I felt that the ephemeral work, which would be left in place, should only be made with natural materials.

Above: Marram grass plait 2, 2024. Marram grass plaited on location, Alnmouth, Northumberland.

Sitting among the marram grass at the back of the beach, I started to plait stems together – these were still rooted and the leaves weren't damaged by my manipulation; they were strong and flexible, coming together to form the beginning of a possible vessel, but allowed to trail off into the surrounding leaves. The second plait was longer, similarly still rooted, and formed a kind of plaited windsock among the other leaves and stems. How long these will have remained in the formation I gave them I don't know. I photographed them and then walked on. Maybe the wind worked them apart in a matter of minutes or perhaps they were still there days later.

Below: Marram grass plait 1, 2024. Marram grass plaited on location, Alnmouth, Northumberland.

The next day, walking in the village, we passed a house with a climbing plant clinging to the frontage. The autumnal leaves had mostly fallen, and the brightly coloured leaf stems left piled up against the base of the wall. These stems grabbed my attention and a handful provided all I needed for a small woven structure. As the stems were still relatively fresh, they had some flexibility but also enough rigidity to hold themselves in place once woven together. Placed back on the ground among the other stems, they appeared as if they had just arranged themselves from the random gathering into a more organized patch.

It is important to remember when working spontaneously with materials that haven't been prepared by drying (which is an important step when working with natural materials), that this drying and subsequent shrinking will naturally happen anyway. Therefore, a structure made with fresh plant material will change as it loses its water content. If a piece is to be left on location, then its integrity is of no concern. If this structure is to be kept, then it will inevitably loosen as it dries.

Opposite: Woven climber stems, 2024. Freshly fallen leaf stems, woven on location, Warkworth, Northumberland. 15×15cm (5.9×5.9in).

Below: Gathering stems on location.

87

Another beach walk and this time I gathered a handful of wind-blown stems. These long stems lent themselves to a simple coiled vessel. Tucking bits in and round the other stems to stabilize the construction, I formed a loose nest-like structure. Placing this vessel in a couple of different locations on the beach to photograph it was an interesting way to see how the materials I had gathered interacted with the various parts of the beach – stone, driftwood and dune grasses.

Other bits I picked up became short lengths of cordage, wrapped and stretched across driftwood. This time my experiments were less resolved, less satisfying perhaps, but nonetheless I learnt something through handling and manipulating each of the materials. Selecting and playing with the materials in my hands, out on the beach, then deciding where to place them before walking on gave a lovely creative focus to the visit.

Opposite and below: Coiled vessel, 2024. Beach-combed materials, manipulated and left on location after photographing in different parts of the beach. Approximately 20×20×10cm (7.9×7.9×3.9in).

Embracing Change

It was a different time and place, but again I was working with materials gathered on location. Weaving with hazel twigs that I had picked up earlier the same day, I became aware of the detail of the bulging leaf buds on the ends of each branch. I wondered if these still had the potential to open, even if incorporated into the woven structure. By evening I had completed the weaving, using the stitched twining method (see page 40). I removed the piece from the frame and stood the bottoms of the twigs in a pot of water in the hope that they might open.

Left for a couple of days, sadly the buds didn't open further, and I think perhaps it was too long since the branch had fallen – possibly several days – before I picked it up. However, this had sparked a thought: embracing the ephemeral in weave could also mean making a piece that would then shift or change, even if relatively temporarily. Could gathered stems be worked with and then still allowed to flower or break into leaf? Could seeds be sown within the body of a piece of weave and then go on to germinate and grow? These fleeting changes could be observed and enjoyed, purely in the moment. They could be sketched or photographed, capturing the changes in a different medium.

Above: Material Sketches, 2024. Linen, sycamore keys, oak twigs with acorn cups, blackthorns. 28×9×4cm (11×3.5×1.6in).

Opposite: Hazel Weave Material Sketch, 2024. Stitched wrapped twining, hazel twigs, cordyline fibre, linen warp. 26×16×4cm (10.2×6.3×1.6in).

91

Chapter 6

MATERIAL CHOICE

Opposite: The String Drawer (detail), 2024. Repurposed picture frame, re-used cotton warp, woven string fragments. 29×21cm (11.4×8.3in).

Pushing the Boundaries

MATERIAL
the matter from which a thing is or can be made.

The Latin root of the word material is *matr*, which means mother or origin. In our contemporary understanding we think of material as something physical, basic even. Materiality is the character or qualities of any particular 'thing'. As I think of these terms, I can't help but be aware of my hands and how much materiality is tied to the feel of things held or touched. Material is defined by basket-weaver Hilary Burns as 'whatever you can lay your hands on'[15], which speaks of a lovely open-minded approach to the potential of what we find around us at any point in time or place.

There is a set of conventions within the world of weave, just as there are in any craft. Those conventions are often there for very good reasons – they are what works. It's important not to dismiss these in favour of experiment, but there is a balance to be found between convention and 'anything goes'. It can be that through the pushing of boundaries, stepping sideways and trying things out, we discover new ways. Unconventional material choices may lead us in new directions. If something works with one material, then why not try it with something different – perhaps a found or

Above: Headphone Weave Material Sketch, 2024. Repurposed headphone cable, woven on pin loom in one continuous warp/weft structure. 12×9cm (4.7×3.5in).

repurposed thread instead of one purchased specifically for that task? Likewise, choosing to make a conventionally simple structure with an unconventional material can bring a whole other set of qualities and can be an exciting development.

Unconventional materials could include many of the wild or foraged plant fibres available to us. While being mindful of a few basic principles – allow them to dry (and therefore shrink) first, then dampen prior to working and introduce twist to add strength – the best way to learn how to work with them is to try. Some will be brittle, others surprisingly strong. Each will require different handling or suggest different techniques and outcomes. The more you work with any material, the more you will learn about its potential, and your confidence will grow.

The house, shed, garage and garden can be rich sources of 'wild' materials to work with. Cloth, paper, plastics and wires can all be incorporated into woven structures. Many of these could be twisted into cordage (string) in order to then weave with them, or they might be used in strips, or as they are. Deconstructed items, such as hosepipe, bicycle inner tube, packaging, even old musical-instrument strings, could be repurposed. These are the types of material that would be thrown away once their original use is no longer possible due to weakening, piercing or breakage. Why not play with these thread-like materials instead of putting them straight in the bin? Jessica Brouder's choice of materials appears playful and experimental. Her use of old yoga mats is what first caught

Below: Inner Tyre Weave Material Sketch (detail), 2024. Repurposed bicycle inner tyre, plain weave. 20×22cm (7.9×8.7in).

my attention on Instagram (see page 104). There appears to be a joy in working with these flexible synthetic surfaces, transformed from a functional item whose purpose is far removed from the weaver's loom.

Some material choices might be about embedding a narrative in the work. Working with materials that hold sentimental value or personal meaning can bring a focus to a series of work that is unique to you and your relationship with the material. Philippa Brock's ongoing series *Dead Mother Collective* is an example of this way of working, with materials that have a very personal connection (see page 98).

Out and about, we might find potential materials in the park, walking in the woods, or visiting different locations. Beaches can often provide fragments of rope, sticks or feathers. Even long strands of seaweed might suggest threads to you – as long as you can cope with any seaweed aromas these might bring with them!

Above: Paperclip Weave Material Sketch, 2024. Paper yarn, old paperclips. Test piece for *Book Marks* project. 6×8×3cm (2.4×3.1×1.2in).

Left: Root Weave Material Sketch, 2018. Red kale stems with root, twining in sweetcorn fibre cordage. 21×16×8cm (8.3×6.3×3.1in).

WILD WEAVERS
Philippa Brock

Philippa Brock is a UK-based woven-textile researcher, artist, designer, curator and editor who has had a portfolio practice since 1994 and, until recently, was running the Weave department at Central Saint Martins (part of University of the Arts, London). Her main practice lies in 'disruptive' methods for both analogue (hand-woven) and digital (power-loom woven) jacquard. She has a reputation for her sustainable, experimental, obsessive, 2D to 3D self-folding textile concepts, where the textiles self-form or assemble as they come off the loom, resulting in innovative 3D sculptural surface effects. These resultant textiles are situated within a liminality of design and fine art, they are exhibited internationally in galleries, and used within the fashion and interior textile industry.

During the Covid-19 lockdown, without access to hand or power looms, Philippa developed off-loom woven series, including *Etudes: The String Revolution*, a series of repetitive plaited studies, and the *Dead Mother Collection*, a series exploring her late mother's collection of domestic fabrics.

The *Dead Mother Collection* took a material-memory approach to remnants and meterage of both used and unused textiles collected over 70 years, intended for dressmaking and interiors projects. Growing up in a large household where textiles, dressmaking, craft and embroidery projects were always on the go, Philippa and the other children were given choices of the type, pattern and colour of the fabrics that were going to be used for items such as pyjamas, dresses, duvet covers or curtains. With additional inspiration from Michel Pastoureau's book *The Devil's Cloth*[16], which explores the historical biases, interpretation and use of striped fabrics, this resulted in the initial striped works of the series.

Opposite and below: Dead Mother Series, 2020 (ongoing). Repurposed cotton, newspaper. Cotton fabric cut into strips and hand woven in mainly plain weave structures. Newspaper backing torn to shape. Woven textiles stitched onto the newspaper for stability and to nod at quilting techniques. Each work approximately 13×13cm (5.1×5.1in).

The *Dead Mother Collection* explores ideas around patchwork, which traditionally reuses and recycles textile scraps, such as preloved or discarded clothing, or interior textiles that are worn out or that have no particular use. Her process involves cutting the fabric into strips, then hand weaving these and stitching them onto newsprint to stabilize their woven structure. (Newsprint was traditionally used to line quilt pattern pieces, to add stiffness for stitching, and either removed or kept in the quilt pieces for warmth.) The *Dead Mother Collection* is ongoing, currently standing at around 260 pieces.

WILD WEAVERS
Polly Pollock

Polly Pollock is a UK-based artist whose work combines basketry and stitched textile techniques. Polly works mostly with paper yarns, which she dyes using gentle ecodyes, often produced from vegetable peelings, tea leaves and other kitchen waste, to give soft and gentle colour palettes. Polly aims to ensure her work, albeit in small ways, avoids contributing to the mounting levels of waste in the world today.

Some years ago, Polly began exploring themes around care, protection, nurture, damage and repair. Her *Once in a While* series began from a small idea, while she was considering darning as a form of repair. Polly made a small loop of palouti cane, worked a grid across the loop and began weaving – darning – across the grid. It was a fairly unconscious exercise, as if sketching or doodling, as she explains:

'I was just using leftover scraps of material – it was very unthought through at this point. As often happens, it's the chance experiments, playing with materials, which lead on to ideas you want to continue exploring – so I made more experimental pieces using different scraps of materials. This led me to intending to make 52 pieces – one a week – for a year, needless to say it didn't happen quite like that! "One a Week" stretched into making more pieces in an extended and sporadic way, hence the 52 pieces becoming "Once in a While…".

'I've a limited supply of palouti cane as it's no longer available in the UK, so making new pieces will come to a natural end. I used almost entirely short lengths of leftover materials for weaving, fitting in with the somewhat incidental way I've worked on this body of work over time.

'I really enjoyed developing many different ways of working into small defined spaces: changing the grids, some very regular, others quite random, sometimes close grids, others more open.

Opposite and below:
Once in a While ….. (Detail), 2020. Palouti Cane and various scraps of threads & yarns including paper, hemp, flax, cotton and raffia. Varying dimensions within 15cm (5.9in).

'Each variation presented new opportunities: some grids "pulled" more under tension when weaving, creating irregular shapes; varying weaving materials and methods; adding stitch or knots, leaving open spaces, weaving tightly and densely with fine materials, combining different materials. Each piece in turn led to more ideas and so on. I'll continue making these small pieces until I finally run out of palouti cane.'

WILD WEAVERS
Joseph Cawthan

Joseph Cawthan is a young visual artist, designer and climber, currently based in Glasgow.

Climbing on coarse gritstone presents a series of challenges, one of the less obvious being the protection of one's fingertips. After a few hours on sandpapery rock, the would-be ascensionist starts to feel a burning sensitivity on their finger pads, along with a loss of precious friction – the climb literally slipping from their fingers. To solve this, rock enthusiasts have taken to mummification – wrapping their sore fingers in a tight spiral of tape to act as a second skin. Joseph has allowed such climbing experiences to inform his first weaving project, as he explains:

'This project was my first exploration into the weaving process and a departure from my regular practice. I was taken by the potential of the technique to translate a period of my climbing into a physical artifact. I was interested in how the tape could be used as an index. To climb a rock is a fleeting experience, the resultant tape is a textile materialization of the ephemeral deeds of its user.

'The weft in this sample was collected over a week of gritstone bouldering. Each dirtied length of tape represents an effort to push past the limitations of my own skin. Now combined, it symbolizes a rare week doing what I love in a deeply personal, textile language.'

Opposite and right:
Reading Week (4–10/11/2024), 2024. Cotton warp, climbing tape weft. Woven on rigid heddle loom. 29×7.5cm (11.4×3in).

103

WILD WEAVERS
Jessica Brouder

Jessica Brouder is an Irish Canadian visual artist and art educator living and working in Tiohtià:ke, Montréal. Informed by an appreciation for folk art and vernacular craft, Jessica's practice begins with locally collected environmental and societal debris as the primary conceptual and material source. Her process often involves the repetition of rupture, cutting or breakage, followed by a reconfiguration. The weaving or assemblage stage represents a kind of reparation, organizing a mess of threads or images. Through the material and processes involved in the making of woven structures she explores themes of memory, transformation and the cycles of discard.

 Jessica collects yoga mats locally, both online from individuals and directly from yoga studios, where they have been abandoned or forgotten. These PVC mats, made of long-dead organisms in the form of fossil fuels, still hold the histories of body weight, movement and time spent breathing in and out. Some are marked by names and phone numbers. All are cut into threads and joined together in a plain-weave structure. These plastic portable pieces vary in colour from side to side. Their surfaces are embossed with patterns recalling the millefleurs that decorate the background of medieval tapestries.

 Jessica often utilizes a square-like format echoing a sample quadrant – a method for counting used in ecology, geography and biology to identify, record and estimate numbers of species in a sample area – to organize the work in a manner that mimics a human-centred view, observing the ground surface

from above; thinking about soil as a place where transformations happen, where whole life cycles, processes of 're-mattering', are happening.

The tabby/toile surface lends itself to paint. Jessica's process involves a continual unravelling and reassembling of forms, creating compositions that evolve in unpredictable ways. By unweaving and reweaving the mats, she breaks down and rebuilds surfaces, revealing hidden narratives that reflect the dynamic relationship between material, time and process, thus allowing the material and objects to tell us something about themselves.

In the process of the weaving, image becomes object and object becomes image simultaneously during construction. To further enhance the sculptural quality of her weavings, Jessica employs individually made bronze nails as an extension of the work. Here, bronze is used to highlight and give attention to the hardware, the support structure, the parts doing the holding.

Above: Worms and Seeds, 2022. Weaving, used yoga mats, salt dough with cinnamon, coffee grinds and turmeric, plastic bread ties, oil, acrylic and spray paint. 42×50×6cm (16.5×19.7×2.4in).

Opposite: Detail of above.

Chapter 7

WEAVING PLACE

Opposite: Daffodil Weave material Sketch (detail), 2023. Daffodil stem warp with twining in daffodil leaf. 58×6cm (22.8×2.4in).

Place Making

I see most of my work as being about 'place', even if this may not be immediately obvious to the viewer. In my mind there is a significance attached to where my materials come from. I like to separate materials from different locations because I see them as tangible links to the places I gathered them from. Depending on the type of material, this separation by location is sometimes easier to achieve for some than for others. For example, if I am collecting dandelion stems, I generally want as many as I can get at the point in the year when they are long and strong. This means a short window of opportunity. Focused harvesting at this optimum time will enable me to make a large piece of work later in the year with this one material. I will gather the dandelion stems wherever I can during this period, and so the work then becomes about the material, rather than a record of a specific location.

If I am exploring a new place, getting to know it and finding ways to connect with it creatively, I will gather materials there. This may be because I know I can use them in a particular way, or they may capture my interest to somehow sum up my experience of that place. If this includes gathering dandelion stems, however, then I will keep those stems separate from those gathered elsewhere, because in this instance I am looking for a specific connection to this new place.

I also attach significance to materials that I have gathered or found myself. As Caroline Dear states: 'Memory is enfolded into an object when we handle the material to make it.' [17] It is important to me that each stage of the process has passed through my own hands. If I am given a found object or a bunch of usable materials by someone else, I can't ever feel the same connection as I would if I had found or gathered them myself. This may seem pedantic, but it is how my creative brain works, and it is this that helps me be truly connected to the materials and the places they came from. I feel that this provides an authenticity to my relationship with my work and the places connected to my work.

Waiting for the Ferry

This piece was made after a holiday in the Outer Hebrides. We had spent some time at Uig pier, waiting for the ferry. I find such places fascinating with their mix of working boat paraphernalia, gentle tourist activity, and general comings and goings of people and vehicles. There were piles of ropes and straps from the fishing boats; stacks of netted fishing creels and lobster pots; rusty metal loops and hoops – lots of visual interest in textures, structures and colour. I picked up a few small rusty objects as we wandered about the harbour area. Once home, these were incorporated into a long, narrow, woven linen strip, made on my floor loom, in response to all those ropes and straps left in heaps around the pier. The strap-like strip was then soaked in seawater, to mimic the action of the sea and allowing the rusty metal embedded in the weave to stain the cloth.

Opposite: Waiting for the Ferry, 2018. Linen, found objects, rust staining. 22×16×9cm (8.7×6.3×3.5in).

Artist in Residence

Residencies are a very specific way of focusing creatively on a new place. For some artists, a residency situation can provide a retreat from everyday life, and an opportunity to concentrate on their work without the usual distractions. For others, this may provide a new and exciting place-based focus: permission to really sink in to a location and to get to know it by engaging creatively with the place and its material. While some residencies are formally arranged, applied for and supported by organizations, you could organize your own residency situation purely by visiting a place regularly or by staying there for a period of time, thus allowing yourself the space and time to engage and create. I treat my allotment plot as a kind of long-term residency situation, exploring its potential for providing materials and inspiration on an ongoing basis. (If you want to find out more about how I interact with my plot, do take a look at my book, *Wild Textiles*.)

I have also spent time away on residencies much removed from my domestic situation. Getting to know a new place and the different materials available there takes time. If multiple visits can be made, a more seasonal spread of knowledge and engagement with a place can be all the more satisfying. Visiting and working in residence in the ancient Cornish farmstead of Kestle Barton in each season of the year allowed me to connect with the place and its plants as the seasons shifted. I walked each day and gathered materials, but also spent time getting drawn in to the detail of the place. I was fascinated in winter by the bare hedges, muddy lanes and remains of last year's growth in the garden. I enjoyed observing how these changed as the seasons unfolded. I made dye-based inks with whatever plant material I could gather – apple-tree prunings from the orchard, and other fallen branches; fallen lichen; oak galls; berries and flowers (gorse, daffodil, dried buddleia) – extending my colour range with the addition of iron to some of these. I also collected mud (from the nearby Frenchman's Creek and the various tracks) and added those to my colour palette. Some of these inks went into sketchbook work to visualize ideas in the studio.

Seasonal shift – details noticed:
- **Winter** – bare hedges, muddy lanes, plant stems and remaining seedheads, orchard pruning and garden tidying.
- **Spring** – fresh green energy bursting through the winter bareness, lush green carpeting the woodland floors, wet everywhere, alternating sounds of bird song and heavy rain on the roof.
- **Summer** – flax ready to harvest, colour and abundance everywhere, meadow buzzing with insect activity.
- **Autumn** – harvest moon, swallows gathering above the orchard before flying south, plants tiring, hedgerows full of fruit and seed.

Below: Twigs and Buds Material Sketch, 2024. Stitched wrapped twining with twigs, linen. 18×10×10cm (7.1×3.9×3.9in).

Opposite: Pine Needles Material Sketch, 2024. Pine needles, twining in silk dyed with apple wood. 16×13cm (6.3×5.1in).

Other materials I collected went into the studio to experiment with, by making a series of 'material sketches'. Each new combination of materials required a period of learning, understanding how to handle and work with them. I am often using familiar techniques, but they will feel different with every material. Each thing I try opens up the next set of possibilities and, through the work, I am drawn in to the detail and nuances of each material. Often it is in the standing back, reflecting, curating and photographing, that relationships between these 3D sketches are revealed, and even more possibilities present themselves...

What resulted by the end of the year was a series of these 'material sketches', along with my collected colour palette. These physical, three-dimensional experiments told the story of my engagement with the place, as well as a learning journey on which I discovered how to work with some unfamiliar materials. Not everything worked as I expected or hoped, but there were also discoveries and revelations along the way. Using weave, netting and particularly stitched twining, I was able to use a variety of found materials that spoke of the place through the shifting seasons.

The kinds of materials which might offer a starting point for place-based weaving include:

- Twigs and sticks – it is best to let these dry before using them in case they shrink.
- Plant fibres suitable for cordage, such as nettle fibres, long leaves, dandelion stems (for instructions on gathering, drying and processing, see my book, *Wild Textiles*).
- Small objects that might be incorporated into a woven structure – wood, stone, seed, shell, feather, metal, etc.
- Roots, leaf stems, seedheads – it is tempting to gather very fragile stems, which will often break when you start to work with them; however, you can learn so much through trying things out, and sometimes they will surprise you as you learn how to handle them gently.
- Ropes, dried seaweed, old bits of net – found on beaches or in coastal locations.
- Repurposed fabrics or papers that speak of a place or hold memories.

Purity of material

When I am working with plant fibres, I find the most satisfaction in using one material at a time. I am attracted by the purity of using one plant for the whole piece of weaving. This could be in a continuous warp/weft structure, as in the example of *Dandelion Weave* (above); or it could be using the stems for the warp and softer parts of the same plant as the weft. Using only one plant fibre at a time allows for the inherent subtle variations in tone to shine through, and this can reveal a beauty in materials that are often overlooked. Each fibre has its own subtle differences and thus there is an adjustment in the hands as to how it is handled, how it feels, its aroma, and so on…

When I am teaching workshops on how to gather, extract and process plant fibres for use in cordage and then subsequent structures, a common question is whether, or how, to mix different fibres. My response to this is that I generally don't feel the desire to mix different fibres, preferring to use them individually, to celebrate the unique characteristics of each material in turn. Of course there are no rules on this, so if you feel you want to bring different fibres together, go for it. The main thing I would recommend is getting to know your materials individually first, so that you can understand how they might have different strengths, and absorb water differently, and dry at different rates and into different states of fragility.

Using a pin loom, it is possible to create a woven structure from one continuous length of thread or cordage. This process lends itself to working with hand-twisted cordage because you can add more on to the length as you go; and, therefore, you don't have to make the whole thread and pass all of it through each warp time after time, which would otherwise catch and potentially break. Start with a loop at the beginning of your cordage and hook this onto the first pin. As long as you make enough cordage to wind onto the pins to form the warp and to weave the first weft row, the structure will work. More can then be added to the length, woven in and then repeated, until the last row is formed, when the string is fed through the starting loop to complete the piece before lifting it off the pins. See my book, *Wild Textiles*, for more information on cordage making and how to approach different materials.

Above: Dandelion Weave 3 (detail), 2021. Dandelion stems (*Taraxacum officinale*). Stems, gathered after flowering, dried, manipulated to form cordage and then woven together in one continuous warp/weft structure. 30×30cm (11.8in) (unfolded).

Opposite: Field Fragment Flax Triptych, 2023. Allotment grown, hand processed and spun flax fibre woven on flax stems (*Linum usitatissimum*). 143×43×7cm (56.3×17×2.8in) each.

Stem as warp

Using plant material (stems and sticks) instead of a conventional warp to create woven structures means that it is possible to make quite rigid or even sculptural pieces. Flax stems tend to have a lovely straight habit and don't branch until near the top, so they will sit neatly next to each other in a row and form a relatively strong set of warp 'threads'. I have worked with them as a stiff warp in both retted* and unretted states.

The presence of the strong linen fibres means that the stems will be relatively sturdy, despite being slim. Using the stems in an unretted state gives an even more stable structure, as the stem (and all its constituents) is entirely intact. The main challenge with this kind of structure is in stabilizing the 'warp' as you start to weave. I tend to use a strip of rigid card (repurposed grey board from the back of sketchbooks or mount-board offcuts are ideal), in front and behind the row of warp stems. I hold these together with small clamps or clothes pegs at either end, keeping the stems in order and sitting in a row rather than crossing at all. Clamping the whole thing to a wooden frame can help too. Once I've woven a few rows, it can also be useful to stitch through the structure and tether it at either side to a frame. This kind of improvisatory stabilizing is worth experimenting with; different strategies will lend themselves to different situations, depending on the length of the stems, the width of the weave, and the structure's ultimate size.

*Retting flax is the process by which the stems are allowed to rot in a controlled way so that the fibres can be separated from the core of the stem. This process involves either soaking the stems in water for a period of time or laying them out on grass to 'dew ret'. In both cases, the dampness promotes bacteria, which break down some of the pectins in the stem. See *Wild Textiles* for more information on this process.

This approach can work on a variety of scales. My early experiments were on leaf stems, gathered in the autumn and allowed to dry. As is often the case, testing out the idea on a small scale gave me confidence and led me to working at a more ambitious scale, with different materials. *Field Fragment Flax – small sample* shows working with sections of flax stems, celebrating the roots of the plant, which remain on the stem as the whole plant is pulled out of the ground at harvest. *Field Fragment Flax – tryptic* takes this idea back to the whole stem, with the woven element extending 60–70cm (24–28in) from just above the roots, along the straight part of the stems and into the branching tops of the plant. This trio of pieces, made to sit next to each other, was inspired by the idea of the plants in a section of the flax field being lifted from where they had grown and being set in place, forever standing in their shoulder-to-shoulder habit.

Another example using a similar approach to the *Field Fragments*, but this time using daffodils as the material for both warp and weft, is *Daffodil Weave*. The stems and leaves of daffodils can be gathered just at the point when they have gone over and start to yellow, having sent their strength back into the bulb for the next year. Gathered and dried, they make a good material to work with in a variety of weaving ways. The stems have more stiffness than the floppy leaves, and so I felt they would lend themselves to the kind of structure I might want in a warp. Leaves are twined between these stems, at first as straight lengths and then bent carefully in half to give a shallower but wider warp from the same number of stems. The weaving of a piece such as this reveals the beautiful tonal variation in the leaves: as they are twisted and laid across each warp, the nuances are presented in their fine detail – golds, yellows, honeyed and toasted browns, pale and dusky tones. I don't consciously place these tones; they are arranged randomly as I take each leaf in turn from the damp cloth where they are prepared for weaving.

Below: Flax Root Weave, 2024. Allotment grown, hand processed and spun flax fibre woven on flax stems (*Linum usitatissimum*). 20×18cm (7.9×7.1in).

Opposite left: Ash Leaf Stems Material Sketch, 2021. Ash leaf stems, hand processed and spun flax/linen, apple twigs. 29×14×9cm (11.4×5.5×3.5in).

Opposite right: Daffodil Weave material Sketch, 2023. Daffodil stem warp with twining in daffodil leaf. 58×6cm (22.8×2.4in).

Last Thoughts

It is good to take a step back, to review and reflect. I love sharing my work in a variety of ways, and it is a privilege to be able to do that through *Wild Weave*. In bringing together my thoughts and practical research for this book, I am aware of themes and branches emerging through my practice. There are some areas where I am still captivated creatively by ideas or processes that I was working with a number of years ago, and that may have been similarly referenced in *Wild Textiles*. The underpinning of environmental concern and a desire to work as sustainably as possible are constants, and my material choices will always be firmly guided by these principles, even if I push on (ever curious) and find ways to work with new ones. There are some new preoccupations in technique that have emerged to hold my focus in my current work.

In the process of writing and sharing those preoccupations with the reader, there is inevitable reflection on my practice. It feels right that things are always moving on and my work is evolving. I would not be satisfied with producing the same work repeatedly. And yet we do all have some elements of process or material that we just can't leave alone. My friend and colleague Siân Martin talks about her father's view that 'you only ever do one piece of work in your life', and when asked how long it took him to do a particular piece, Edward Martin's response was 'I give them my age'. Everything is interconnected and each thing we make builds on the experience of everything that came before – it is all part of a personal creative continuum.

Opposite: Book Mark Object (detail), 2023. Repurposed book section, manipulated by paperclip insertion with woven paper cordage. Part of Book Marks Series. 16×13×5cm (6.3×5.1×2in).

Glossary

Braiding: passing three or more strands of material over and under each other alternately, at a diagonal angle, to create a narrow strip of fabric. Also known as plaiting.

Coiling: a continuous coiled core, which is wrapped and stitched to itself, beginning in the centre and working outwards and upwards.

Cordage: a two- (or more) plied string, formed from twisting fibre in one direction and plying against another at the same time.

Fibre: a single thread-like filament, natural or synthetic, that can be spun to make yarn and constructed into cloth.

Knotting: the action of tying knots in yarn to construct a textile surface, especially when making rugs.

Loom: a machine, often constructed mostly from wood, used to hold warp threads under tension in order that weft threads can be passed between them and interwoven to form cloth.

Looping: where one strand is pulled through loops in sequence (this is different from knitting or crochet where loops are passed through each other, worked from a ball, without the whole length passing through each loop).

Netting: open-meshed material made by knotting together twine, wire, rope or thread.

Plaiting: see *Braiding*.

Shed: a space formed by lifting some of the warp threads to allow the weft to easily pass through, often using a shuttle, facilitating weaving.

Tapestry: a woven textile structure created on a loom or frame where the weft threads are beaten down to cover the warp threads.

Twining: using two or more weavers (weft) at the same time, switching places front to back in turn. Referred to as waling in basketry.

Warp: a set of yarns running lengthwise (vertically) and often held under tension on a loom, so the weft can be interwoven perpendicularly.

Weave: vertical strands as warp and horizontal as weft, creating form with tension.

Weft: a set of yarns interwoven with the warp, running horizontally to form a woven cloth with the weft.

Yarn: strands of natural or synthetic fibres or filament, often spun together and plied, used for sewing, weaving and knitting to construct a cloth.

Notes

1 Kary, N., *Material: The Art of Handcrafting Beautiful Objects in a Digital Age,* Chelsea Green Publishing, 2020 (p.75)
2 Albers, A., *On Weaving,* Wesleyan University Press, 1965 (p.22)
3 Wayland Barber, E., *Women's Work: The First 20,000 Years – Women, Cloth, and Society in Early Times,* W W Norton & Company, 1996
4 Hemmings, J., *Warp and Weft: Woven Textiles in Fashion, Art and Interiors,* Bloomsbury, 2012 (p.88)
5 Albers, A., *On Weaving,* Wesleyan University Press, 1965 (p.62)
6 Hemmings, J., *Warp and Weft: Woven Textiles in Fashion, Art and Interiors,* Bloomsbury, 2012 (p.8)
7 Stritzler-Levine, N. (ed), *Sheila Hicks: Weaving as Metaphor,* Yale University Press, 2006 (p.18)
8 Stritzler-Levine, N. (ed), *Sheila Hicks: Weaving as Metaphor,* Yale University Press, 2006 (p.43)
9 Smith, P J., in Butcher, M., *Contemporary International Basketmaking,* Merrell Holberton, 1999 (p.11)
10 Rossbach, E., *Baskets as Textile Art,* Van Nostrand Reinhold Company, 1973 (p.66)
11 Stephanie Bunn in Bunn, S. & Mitchell, V. (eds), *The Material Culture of Basketry: Practice, Skill and Embodied Knowledge,* Bloomsbury Visual Arts, 2021 (p.6)
12 Butcher, M., *Contemporary International Basketmaking,* Merrell Holberton, 1999 (p.31)
13 Stephanie Bunn in Bunn, S. & Mitchell, V. (eds), *The Material Culture of Basketry: Practice, Skill and Embodied Knowledge,* Bloomsbury Visual Arts, 2021 (p.2)
14 Butcher, M., *Contemporary International Basketmaking,* Merrell Holberton, 1999 (p.11)
15 Hilary Burns in Kary, N., *Material: The Art of Handcrafting Beautiful Objects in a Digital Age,* Chelsea Green Publishing, 2020 (p.67)
16 Pastoureau, M., *The Devil's Cloth: A History of Stripes,* Atria Books, 2003
17 Caroline Dear in Bunn, S. & Mitchell, V. (eds), *The Material Culture of Basketry: Practice, Skill and Embodied Knowledge,* Bloomsbury Visual Arts, 2021 (p.113)

Further Reading

Collingwood, P., *Textile and Weaving Structures: A Source Book for Makers and Designers*, Batsford, 1987

Fox, A., *Findings,* Stitch: Print: Weave Press, 2016

Fox, A., *Natural Processes in Textile Art: From Rust Dyeing to Found Objects*, Batsford, 2015

Fox, A., *Plot 105*, Stitch: Print: Weave Press, 2020

Fox, A., *Wild Textiles: Grown, Foraged, Found*, Batsford, 2022

Garodia, R., *Contemporary Weaving in Mixed Media*, Batsford, 2022

Harding, S. & Waltener, S., *Practical Basketry Techniques*, A & C Black Publishers, 2012

Lawty, S., *Earth Materials*, Flow Gallery, 2017

Marein, S., *Off the Loom: Creating with Fibre*, Studio Vista London, 1972

Neumüller, K., *Simple Weave: Weave Without a Large Loom*, Batsford, 2023

Schimmel, P. & Sorkin J. (eds), *Revolution in the Making: Abstract Sculpture by Women 1947–2016*, Hauser & Wirth, Skira, 2016

Simon, J. & Faxon, S., *Sheila Hicks: 50 Years*, Addison Gallery of American Art & Yale University Press, 2010

Soroka, J., *Tapestry Weaving: Design and Technique*, The Crowood Press, 2011

The Textile Study Group, *Insights*, Textile Study Group, 2020

Resources

Association of Guilds of Spinners, Weavers and Dyers
www.wsd.org.uk
The Basket Makers Association – The UK's leading organisation for basketry and related crafts
www.basketmakersassociation.org.uk
The Handweavers Studio & Gallery, London – weaving equipment and yarn supplies.
www.handweavers.co.uk
Paperphine – paper yarn supplies
www.paperphine.com
Textile Study Group – professional textile artists and teachers.
www.textilestudygroup.co.uk

Contributors

Philippa Brock	www.theweaveshed.org	@theweavesheduk
Jessica Brouder	www.jessicabrouder.com	@jessicabrouder
Joseph Cawthan	Currently studying at Glasgow School of Art	
Ann B. Coddington	www.abcoddington.com	@abcoddington
Polly Pollock	www.pollypollock.co.uk	@pollypollockbaskets
Jill Walker	www.jillwalker.co.uk	@jillwalker.uk
Jane Walkley	www.janewalkley.com	@janevwalkley
Sarah Ward Podlesny	www.larkandbower.com	@larkandbower

Appendix: *Clutch* materials and techniques

Clutch

1	2	3	4
5	6	7	8
9	10	11	12
13	14	15	16

17

18	19	20	21
22	23	24	25
26	27	28	29
30	31	32	33

34

35	36	37	38
39	40	41	42
43	44	45	46
47	48	49	50

1 Random weave, handspun flax, eggshell
2 Twined handspun flax on dandelion stems, eggshell
3 Twined handspun flax on dandelion stems
4 Twined dandelion stems
5 Coiled and stitched bindweed
6 Random weave, bindweed, eggshell
7 Random weave, handspun nettle, eggshell
8 Twined handspun nettle on sweetcorn husk
9 Coiled split bramble, stitched with handspun flax
10 Random weave, combed soft rush, eggshell
11 Woven handspun flax with linen warp, eggshell
12 Ceramic fragments, wrapped and stitched with handspun flax
13 Random weave, handspun flax, eggshell
14 Looped garlic-leaf cordage, eggshell
15 Looped garlic-leaf cordage
16 Looped garlic-leaf cordage, woad-dyed
17 Random weave, flax 'line' fibre, eggshell
18 Looped garlic-leaf cordage, woad-dyed
19 Wrapped twining, handspun nettle, eggshell
20 Twined handspun nettle on daffodil stems
21 Random weave, combed soft rush
22 Twined daffodil leaf and stems, eggshell
23 Braided daffodil leaf, coiled, stitched with daffodil leaf, eggshell
24 Random weave, daffodil leaf, eggshell
25 Random weave, handspun and woad-dyed nettle, eggshell

26	Random weave, handspun nettle, handspun and woad-dyed flax
27	Coiled handspun nettle, stitched with handspun and woad-dyed flax, eggshell
28	Woven handspun flax, eggshell
29	Woven handspun nettle
30	Woven handspun nettle on flax warp, eggshell
31	Braided soft-rush stems, coiled, stitched with soft rush
32	Looped handspun flax, eggshell
33	Woven daffodil leaf on flax warp, coiled
34	Braided dandelion stems, coiled, stitched with dandelion stem
35	Braided daffodil leaf, coiled, stitched with daffodil leaf
36	Plaited daffodil leaf, coiled, stitched with daffodil leaf, eggshell
37	Random weave handspun nettle, handspun flax
38	Random weave, sweetcorn tassel
39	Random weave, flax 'line' fibre
40	Looped newspaper cordage, eggshell
41	Braided garlic leaf, coiled, stitched with handspun flax, eggshell
42	Plaited garlic leaf, coiled, stitched with garlic leaf
43	Cotton rag cordage, coiled, stitched with threads removed from the cloth, eggshell
44	Random weave, cotton rag
45	Cotton rag, patched and stitched with plant-dyed thread
46	Coiled newspaper cordage, stitched with handspun flax
47	Random weave, bindweed
48	Random weave, bindweed, eggshell
49	Twined bindweed, eggshell
50	Random weave, dandelion stems, eggshell

Acknowledgements

Sincere thanks to:

The contributing artists: Ann, Robert Petersen (writing about Ann's work), Jane, Sarah, Jill, Philippa, Polly, Joseph and Jessica.

Karen and Ryya at Kestle Barton, for their support and appreciation of my practice.

Andrea at JaggedArt, for believing in my work and helping it reach audiences.

Rebecca Armstrong, my editor at Batsford, and Michael Wicks, with whom it is a pleasure to work.

All my family for their constant support, especially Dad (and his string drawer).

And to Mike for holding my hand.

Image credits

All photography by Michael Wicks except the following:
Pages 6–7, 40, 41 (diagram), 42, 43, 51 (below), 52, 82, 83, 84, 85, 86, 87, 88, 89 by Alice Fox
Pages 8, 28, 30, 32, 33, 51 (above), 113, 117 by David Lindsay
Page 11 by Carolyn Mendelsohn
Page 58 by Curtis James
Pages 70, 71 by Bryan Heaton
Pages 72, 73 by Mat Dale
Pages 74, 75 by Sarah Ward Podlesney
Pages 76, 77 by Jill Walker
Pages 98, 99 by Philippa Brock
Pages 100, 101 by Polly Pollock
Pages 102, 103 by Joseph Cawthan
Pages 104, 105 by Paul Litherland

Opposite: Stitched wrapped twining sample (detail), 2024. Paper yarn, re-purposed guitar string, leaf stems, pine needles, silk thread. 22×8cm (8.7×3.1in).

125

Index

Illustrations are in bold

Albers, Anni 9
Allotment 10, 58, 66, 80, 81, 110
Apple wood **8**, **51**
Bases 55, **56**, **57**
Beater **19**, 22
Bindweed (Calystegia sepium) **51**, **56**, 58, 59, 81
Bird feeder **62**
Blackthorns **40**, 42, 43, **45**, **90**
Book 33, 62, 117
Book Marks **26**, **30**, **32**, **33**, 117
Braid 61, **84**, **85**
Bramble 58
Brock, Philippa 96, **98**, **99**
Brouder, Jessica 95, 104, 105
Burns, Hilary 94
Butcher, Mary 40, 48
Card **19**, **20**, 22, 27, **29**, 55, 113
Cawthan, Joseph **102**, **103**
Ceramic fragment 58
Clamps **20**, 21
Clutch 52, **53**, **58**, 59, **61**
Coddington, Ann **70**, **71**
Coiling 55, **56**, 61
Cordage 33, **53**, 55, 89, 95, **112**, 117
Cordyline australis 40, 43, **45**, **91**
Daffodil leaf 58, **59**, **60**, **61**, 81, 114, **115**
Dandelion stems **35**, 50, **56**, 58, 81, **82**, **83**, 108, **112**

Darning 36, 37, **39**, 100
Decay 80, 81, 83
Dorset button 68
Eggshell 52, **53**, **58**, **59**, **61**
Embroidery hoop 37, **38**, 69
Ephemeral 80 – 90, 102
Field fragments 113, **114**
Flax (linum usitatissumum) **2**, 50, **52**, 58, 56, 113, **114**, **115**
Flax retting 113
Formers **18**, **19**, 22, 52, 55, 59
Frame 16, **17**, **18**, 21, 27, 52, 62, 63, 64, 66, **67**, 76, 113
Garlic leaf 58, **61**
Heddle **18**, 22, 27
Hemmings, Jessica 10
Hicks, Sheila 16
Land art 80
Leaf stems **86**, **87**, **114**, **115**
Limpet shell 68, **69**
Loom,
 Darning 37, **38**
 Floor 16
 Pin **19**, 20, 21, 27, **28**, **68**, 112
 Rigid heddle 16, 102
 Table 16
Materiality 94
Material sketches 111, 114
Moss **42**, **43**

Narrative 9, 76, 96, 105

Needle 21, 22, 23, 27, 36, 68, 74

Nettle **57**, 58

Newspaper 58, 99

Paperclips 32, 33, **97**

Paper yarn 6, **31**, 33, **54**, **57**, **59**, **69**, 100, **101**

Place 84, 108, 110, 111

Plait see braid

Pockets **54**, 55

Pollock, Polly **100**, **101**

Residency 110, 111

Roots **96**, 113, **114**

Runner bean stems **50**, 81, **82**, **83**

Rust 33, 108, **109**

Slide 66, **67**

Soft rush (Juncus effusus) 58

Stain **26**, 32, 33, 108

Stitched wrapped twining 40, **41**, **42**, **44**, **49**, 90, **91**

Stone **53**

String **63**, **64**, **65**, **102**

Sweetcorn husk **57**, 58

Tapestry weave 9, 21, 22, 23, 26, **28**, 62, 63, 72, 76

Textile Study Group 58

Twining 55, **56**, **57**, 70, **80**

Walker, Jill **76**, **77**

Walkley, Jane **72**, **73**

Ward Podlesney, Sarah **74**, **75**

First published in the United Kingdom
in 2025 by
Batsford
43 Great Ormond Street
London
WC1N 3HZ

An imprint of B. T. Batsford Holdings Limited

Copyright © B. T. Batsford Ltd 2025
Text copyright © Alice Fox 2025

All rights reserved. No part of this publication may be copied, displayed, extracted, reproduced, utilized, stored in a retrieval system or transmitted in any form or by any means, electronic, mechanical or otherwise including but not limited to photocopying, recording, or scanning without the prior written permission of the publishers.

ISBN 9781849949453

A CIP catalogue record for this book is available from the British Library.

10 9 8 7 6 5 4 3 2 1

Reproduction by Rival Colour Ltd, UK
Printed by Dream Colour, China

This book can be ordered direct from the publisher at www.batsfordbooks.com, or try your local bookshop

Distributed throughout the UK and Europe by Abrams & Chronicle Books, 1 West Smithfield, London EC1A 9JU and 57 rue Gaston Tessier, 75166 Paris, France

www.abramsandchronicle.co.uk
info@abramsandchronicle.co.uk

FSC
www.fsc.org
MIX
Paper | Supporting responsible forestry
FSC® C188448